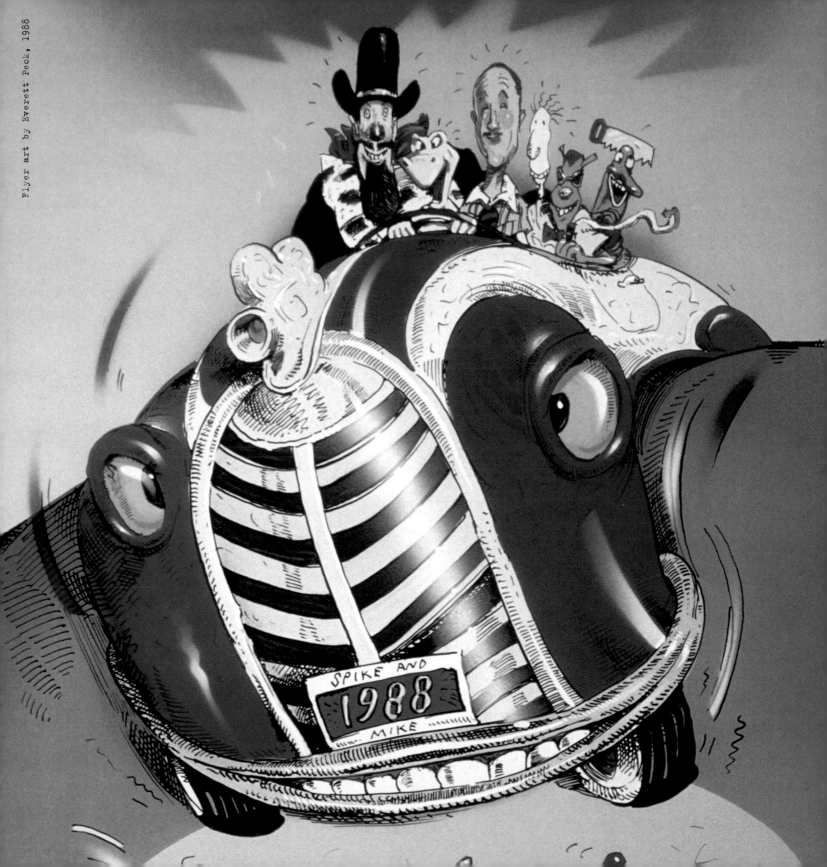

OUTLAW

Cutting-Edge Cartoons from the Spike & Mike® Festivals

ANIMATION

JERRY BECK

Foreword by Todd McFarlane

HARRY N. ABRAMS, INC., PUBLISHERS

Contents

Flash back to the era of the late 1960s, early '70s. Every single Saturday morning, my two brothers and I would slip out of bed while our mom and dad continued to sleep, silently sneak downstairs, and turn on the family television set. We would be well equipped with our bowls of cereal, ready to begin experiencing something that we eagerly looked forward to all week. The thrill was not that we did not have to go to school or that we could spend the whole day goofing around in the backyard.

The highlight was Saturday morning cartoons.

The McFarlane brothers would sit down in front of the television at seven a.m. and remain there until ten. That was the unfortunate hour when our parents would awaken and promptly turn off the TV, announcing that we were watching it too much.

But, in those three magic hours, we got our fill of six shows and the dozens and dozens of characters that helped entertain us throughout our collective childhoods. This was a time when such things as cable television and twenty-four-hour cartoon channels did

not exist. In those days, there were only three major networks, and, if you somehow failed to catch the Saturday morning shows, you were tortured by the knowledge that you had to wait an excruciating seven days before you would see any of those shows again. Not only that, but the following Monday you were guaranteed to be taunted by all your best buddies. In fact, during recess for the entire following week, they would constantly assure me that I had indeed managed to miss the greatest episodes of all time. Now that I am older, it is with great fondness that I look back on those simple, golden moments of animation and cartoons.

Fast forward to the year 2002. The imagery from those days has now become something of a model as to what people believe cartoons should or should not be. Combine that Saturday morning experience with the fact that Disney cartoons had a certain rhythm in putting out cute, cuddly, adorable and accessible characters. When you now try to talk to

most people about animation that is not aimed at an audience of five- or ten-year-old kids, they are confused. They cannot comprehend how a medium that is able to portray any sort of fantasy could actually come up with a story that is not just something that a mom flicks on as a video babysitter for her child.

In my own experience of working three years on an HBO animated series with the Spawn character I created, we got a lot of pats on the back. I always felt half of it was because of the quality of what we were doing; however, the other half was that we were out there swimming by ourselves. I always found it odd—and a little disconcerting—that there have not been more people trying to be aggressive with animation by presenting this medium to a demographic of people who are past the age of ten.

With that, I completely tip my hat to Spike and Mike and the twenty-five years of their traveling festival, which has opened our eyes to the possibilities of animation. Not only has

it given us a look at such iconoclastic animated characters as Beavis and Butt-head and the characters of *South Park*, but it has also shown us glimpses of everything from *The Powerpuff Girls* to cult classics like *Bambi Meets Godzilla*.

Spike and Mike have scoured the globe for decades, looking for people who have devoted a terrific amount of time and energy into creating storylines that appeal to those of us who have an incredible fondness for the animation medium. Some are less concerned that it is animation, but are looking for entertainment on a level that the big, conservative corporations will never admit is a good venue to use. I believe that audiences get starved at some point because the definition of a cartoon does not grow up with us as we age. But animation not only sends powerful messages, it can also show us the artistic possibilities that an entertainment medium can provide.

Even though people have been exposed to the range of possibilities of animation for adults, we are still very limited in what is available to the general public. This is why I feel the great effort Spike and Mike have made in the last couple of decades is unbelievably important. They hunt down these little jewels and travel around exhibiting them to the public. Without people like Spike and Mike we would be limited in our definition of what animation can be.

The Spike & Mike Festivals are often set up in theaters near college campuses, where they introduce a wide range of people between the ages of eighteen and thirty to the American institution of animation. They show audiences that animation can give us anything we want, from cute and cuddly to the most disgusting and diabolical and gross situations possible, with every permutation in between.

That is not to say that everything they have screened is going to sit well with everyone. I know for myself, at the end of a show, I rank all of what I saw in a pecking order. But the important thing is the exercise of continuing to show the public the unlimited potential of this art form. That is the greatest value of the festival, more important than the actual details of any of the specific cartoons. The whole of what their venture has been for the past two decades is far superior to the individual parts.

Given that I've been in the fight to bring some of these ideas to the public myself, it is with enormous gratitude that I thank them for continuing their quest. I hope that for many, many decades to come the Spike & Mike Festival will continue to bring us the adventures of the new animation movements.

Thank you, Spike and Mike. I wish there were a thousand of you.

Todd McFarlane, 2002

The "Sick & Twisted" Story of the Spike & Mike Festival

The current renaissance in animation for feature film, television, and the Web is the result of a collusion of many forces, not the least of which is a handful of extraordinary people who tended independent animation's flame through dark times. Two of them, Spike and Mike, assembled the world's most successful traveling festival of independent animation and took it on the road to audiences across the United States and Canada, beginning a twenty-five-year odyssey that is still going strong. That two stoners from Riverside, California, helped lift this movement up from the ashes is a story worthy of its own "Sick & Twisted" animated film.

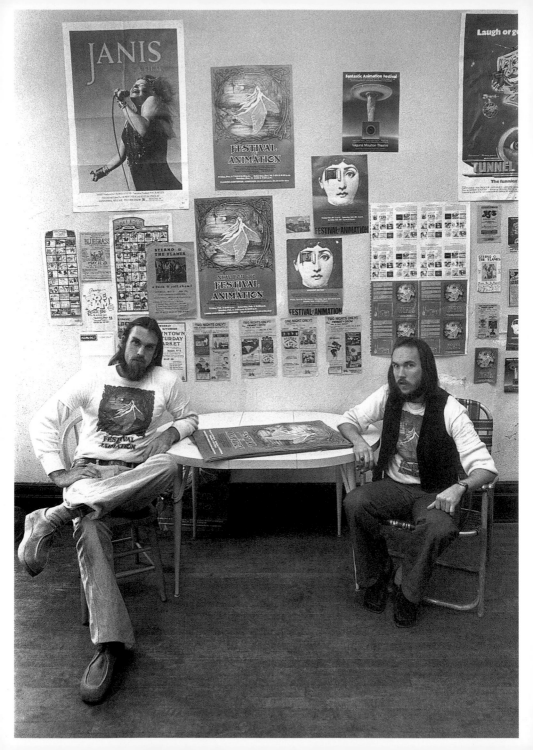

They were not artists, and they were not producers either. Spike and Mike made their living as promoters, and in that sense they were businessmen, sort of. Unlike most businessmen, however, they followed no prescribed path or model, and they started with no real capital, training, or even identifiable ambition, other than to simply keep going and have a good time. It is important to note this here because their reputation for rowdiness often overshadows the fact that their boldness, vision, and willingness to take risks represent the best of the American entrepreneurial spirit. Spike and Mike started from nowhere with nothing, and they went on to create a market where none had existed, making thousands of fans and hundreds of friends along the way. They did it with passion, and even grace, of a lopsided sort. Their contribution to animation history is undeniable.

Animation was never merely a product to Spike and Mike. Rather, it was a cause for celebration, the Thanksgiving turkey around which the world's best animators and most enthusiastic fans were encouraged to gather as a family, to laugh, be amazed, and occasionally pass a joint. They were willing to talk to any animator anywhere, to take a look at whatever idea was being scratched out, and to encourage animators and animation fans whenever and wherever they met them. Many of the leading animators on television and in feature film today, like Mike Judge and Pete Docter, and successful independents, like Don Hertzfeldt and Eric Fogel, got their start with Spike and Mike, who relentlessly invested time, attention,

money, friendship, and love on these artists and their works. Countless animators who did not have the opportunity to contribute to the festivals in the early days were nonetheless influenced by the work that Spike and Mike made available to them. Would that all businessmen were so committed to developing the talent and imagination of the people who provide their goods.

Their street-level marketing approach of papering a town with colorful flyers, and then haranguing it with guerrilla theater performances, is the stuff of legend. Spike and Mike were more Old Testament prophets than profiteers: wild men who went mad in the public square, drawing crowds and delivering their message with the force of a rubber hammer. They ballyhooed on campuses and in coffeehouses and bars, made friends wherever they went, and fed and nurtured those friends over the years. Mike, in particular, always remembered people's birthdays and was willing to celebrate anything, anytime, anywhere, in a spirit of unrestrained joy and generosity. It's safe to say that in nearly every major city in this country there are hundreds of people who have outrageous stories with "Spike and Mike" in the first sentence.

Spike and Mike's tale is not a business history but a cultural phenomenon. They encouraged artists to create in freedom and audiences to enjoy with abandon. Their impact and contribution, though immeasurable, is unmistakable. In order to fully appreciate that contribution, we have to back up the clock a bit, to the mid-1970s, when independent animation, and Spike and Mike, were still down among the ashes.

Spike flyering as a reindeer

UNDERGROUND

Forget what media historians will tell you: The "Golden Age" of animation did not die out in the 1950s; it simply went underground, where all great art goes to wait for the world to catch up.

After the closing of the animation departments at the major Hollywood studios, the medium disappeared from the movie houses, but brilliant animators were nonetheless making a living. In the 1960s and 1970s, many veteran animators turned their hands to uninspired "limited animation" series like Scooby-Doo and the Groovie Goolies, or else worked at just plain day jobs, which freed them to make their own independent films at night and on weekends.

The young generation of animators who came up in this period cut their teeth on TV reruns of cartoon classics and privately

Spike and Mike in 1977

studied well-worn copies of obscure masterpieces such as *Red Hot Riding Hood* and *Duck Amuck*. Like many who grew up with the spirit of the 1960s still lingering in the air, they were subversives all.

Danny Antonucci, for instance, was working on mainstream series like *The Smurfs* and *Richie Rich* by day, while making his earliest designs for the outrageous, utterly eccentric, independent animated short *Lupo the Butcher* by night. Craig McCracken (*The Powerpuff Girls*) was not even born when Warner Bros. closed its animation studio in the 1960s, and yet he and many others absorbed and synthesized the outrageous spirit and powerful techniques of the masters.

Although the new work of independent animators was appealing to the youth subculture of the day, there were few places to go in this country to see it. Independent animated films occasionally found a mainstream audience in the United States, but mostly at museums, midnight rock and roll shows, and sporadic festivals. There were few popular outlets for the unique

visions and irrepressible spirit embodied by the underground movement.

Unlike musicians on underground radio, conceptual artists, and comic-book illustrators of the period—all of whom had fans and means of distribution—an independent animator with a new film was pretty much all dressed up with nowhere to go.

There were other issues keeping independent animation underground. In the 1960s, America birthed a cultural upheaval in the form of the dropped-out-and-turned-on Flower Power Generation, which tended to push the envelope of free speech at every turn. Experimental artists in all media, including animation, were attaining unprecedented levels of heresy, outpacing what networks and theatrical film distributors considered commercial or even appropriate. Film and TV distributors would not have known what to do with a lot of the radical and inspired work, even if they had known where to find it.

Independent animation was ready to come back up into the sunlight, but it needed a champion. Or two.

MELLOW MANOR

In the mid-1970s, Craig "Spike" Decker was a college student renting out rooms in a rambling, run-down Victorian house in the dusty college town of Riverside, just southeast of Los Angeles. Mike Gribble—a charismatic party animal with a heart of gold, an outrageous sense of humor, and a mean golf swing—was living in a cardboard box. Spike was singing with a local greaser band called Sterno and the

Flames, and Gribble was invited to an after-show party.

"Mike showed up with a clown costume on and mirrors on his shoes," Spike recalls. "He was going around the party looking up girls' dresses. The girls' boyfriends got so upset they literally picked him up and did the heave-ho out onto the lawn. That's how I met Mike."

Spike's house was dubbed "Mellow Manor," and rooms could be had for as little as thirty dollars a month including utilities (the larger deluxe rooms were sixty dollars a month). It is safe to say that Decker's tenants were not looking for the quiet of the study hall. He had the fuse box in his room, so if a tenant had not paid his rent, Spike could turn off the power to their room. He remembers, "Girls from the wealthy high school would cut school and ride their horses over to the Manor to hang out, and we'd invite them inside, and their horses would come in too, right into the living room. We were like nineteen or

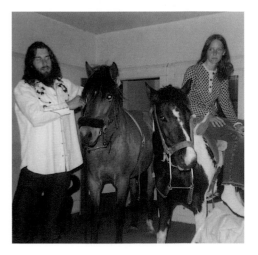

Horses invading Mellow Manor

twenty at the time. We'd prong the chicks, and they'd leave their horses in the living room. When people came over on Harley Davidsons they'd bring them into the living room too. It was notorious." Attracted by the atmosphere, Mike rented Mellow Manor's attic.

PROMOTERS

Once under the same roof, Spike and Mike's chemistry became notorious. "Our parties got raided many times, with helicopters declaring them illegal assemblies," Spike says.

The two began exploring alternative approaches to entertainment distribution. Once, when a friend at the University of California managed to lay hands on a copy of *Deep Throat*, the Mellow Manor boys screened it in the living room, admission one dollar. "Thirteen people got arrested by Vice and Narcotics," Spike says. "They went in the attic and found Mike's stash of marijuana, and one of my guns, and they arrested Mike later and cuffed him, and put him in lockup. I went into hiding for a month. Steve Harmon went and got my gun, and got all the charges dropped, and we got Mike out and beat the rap."

As the relationship progressed, Spike and Mike's unique talents began to emerge, and a strange team coalesced: Spike was the organizer, with a head for the big picture, the details, and money. (Years later, animator Marv Newland described his first meeting with Spike this way: "I remember coming into a hotel room in Seattle, and Spike was lying on the floor talking on the phone with little stacks of cash all around. And I thought,

'Okay, this is very interesting.'") Mike was the people person, the barker and P.R. man, whose irresistible charisma put him in front of the crowd, where he was most comfortable.

Animator Marilyn Zornado (Mike's former girlfriend) remembers that Mike grew up in a military family that moved frequently. "They had lived on [military] bases in Europe, Germany and France, and Mike's mom said they would move onto these bases and within two days people would say to her, 'Oh, you're Mike's mother.' They would be unpacking and Mike would come home with a bunch of boys and say, 'These are my friends!' He was the ambassador of the family."

Spike and Mike loved rock and roll, and it seemed natural that they should become music promoters. So, borrowing money from their parents, they formed Mellow Manor Productions and began promoting Sterno and the Flames. Their initial show was funded by a biker in Riverside who had gotten an accident settlement and loaned them $1,000 after getting a twenty-two-inch steel rod in his leg.

Knowing their Riverside audience intimately, they understood instinctively how to advertise their shows through word-of-mouth, which hang-outs to paper with flyers, and what outrageous graphic to put on the posters. These street-level marketing tactics would become their trademark advertising strategies.

Mostly, however, it was their outrageous sense of spectacle that drew people to them. It was irresistible.

Sterno and the Flames, 1974. According to Spike (kneeling at left), the band was "like Sha Na Na, only greasy."

Spike and Mike had very different personalities, but their differences seemed to bind them in a sort of pact of outrageousness. "They were just opposites," animation producer and longtime friend Libby Simon says of them, "but somehow it worked." Animator Bob Kurtz explains, "They were different, but they fit together, like the pieces of a jigsaw puzzle." Zornado adds, "They were like a comedy team. They would do anything, and they weren't afraid of anything. The world was their stage."

To hear the stories of those who were with them from the beginning, it is clear that Spike and Mike never wanted audiences to just have a night of entertainment, but the time of their lives. They were spring break on wheels, and, in the Southern California rock-and-roll scene, their stunts

and wild charm quickly gained them a reputation for turning any live show into an event.

As Sterno and the Flames gigs became more successful, Spike and Mike began promoting other local rock-and-roll bands. Then they got a new idea: There were concert films of Jimi Hendrix and The Who and other rock bands floating around, why not promote midnight screenings of them? This project became Spike and Mike's first foray into "four-walling," the distribution strategy that they would use throughout their careers in animation.

For film distributors who are not part of the regular Hollywood distribution network, four-walling is one of the only ways to get a film screened. The term refers to renting everything inside the four walls of the theater, which is to say, the auditorium, the projection booth, and—most importantly, since there is no way to know how much money is taken in at a theater unless you count the receipts yourself—the box office. Having dealt with more than their share of unscrupulous venue owners, Spike and Mike would use four-walling as their primary approach to distribution. "We would only do four-walls because we felt that anyone else would rip us off," Spike says. "And so we had this hard-core paranoia pact."

The midnight features were popular, but there was something else. Part of the success of the screenings was due to the curtain raisers that Spike and Mike screened before the features to warm up the audiences. They had gotten hold of some ancient Dave Fleischer *Betty Boop* and *Superman* cartoons, and could not help noticing how much people enjoyed these weird old films. Continuing to promote for live-music venues, Spike and Mike decided to screen some of those old cartoons before the band cranked up. The crowds loved it, so animation quickly became a regular element of the rock-and-roll shows.

Spike and Mike were becoming businessmen, and shrewd ones at that. Mellow Manor Productions was still bankrolled by Spike's and Mike's parents, and they were still debauching the night away back at the Manor, and still just scraping by. There was no chance in hell that Spike and Mike were going to grow up, and no place for them in any conventional version of Big Time promotions. But that was okay. Fate was about to give them an opportunity to make their own way.

Rock-and-roll bands can go flakey all of a sudden, as any promoter will tell you, but it is not a serious problem as long as you can get your investments back. Once, when a particular band that Spike and Mike had booked for a show canceled suddenly, the owner of the auditorium refused to return their deposit.

Spike and Mike had no band, but they did have a rented hall, tickets sold, some old cartoons, and a 16mm projector. Putting their heads together, they made the decision that would launch their destiny.

Cartoons were fairly cheap to rent back then, and there were even some in the public domain, so Spike and Mike decided that what Southern California's stoners needed was not another rock-and-roll event, but cartoons—a whole evening of them, in fact. Quickly, flyers went up for Spike and Mike's first full evening of animation. All hell was about to break loose. It is safe to say that on the night of their first animation festival in 1977, Spike and Mike's audience had not seen much animation, other than *Scooby-Doo* and *Looney Tunes* reruns, or the occasional *Betty Boop* at a Spike and Mike show. It's also certain that they had not seen an evening of animation hosted by the outrageous Spike and Mike. There is no way that the rock-and-roll crowd squinting through the purple haze that night could have been prepared for the full evening of balls-out neoclassic animated shorts like Mel Brooks's *The Critic*, Fred Wolfe's *The Box*, Marv Newland's *Bambi Meets Godzilla*, and others, which Spike and Mike had dug out of the dark vaults of local distributors.

Hippies and stoners who assumed that outrageous art and eccentric humor had begun with R. Crumb and Peter Max were suddenly confronted with unique, unseen short films chock-full of startlingly offbeat humor and wacky takes on human nature. Above all, these old toons were irreverent and way below the radar of mainstream entertainment. It would have been a little like a hippie archeologist sticking his head into King Tut's tomb for the first time and getting a waft of dope smoke.

TAKE TO THE ROAD

While acknowledging Spike and Mike's enormous contribution to animation, Southern California promoter Chris Padilla also suggests that Spike and Mike

got the idea for an "anthology" of animated shorts from him and his partner Dean Berko, who produced a one-shot Fantastic Animation Festival in 1976. According to Padilla, Berko hired Spike and Mike back in June of 1976 to do some flyering for the festival. Spike explains it this way: "We promoted one season of the Fantastic Animation Festival in Laguna Beach, and that did very well, and so we put together our whole package of animation."

Whether or not they borrowed the Fantastic Animation format or not, it is certain that Spike and Mike were aware of the festival, which had a successful six-week run in Laguna Beach, just down the highway from Riverside. In any case, Spike and Mike made the format absolutely their own. Even Padilla admits this. "I find it ironic," he says, "that when I come out with my new animation anthologies I will have to reinvent the programming and marketing strategy I created for the Fantastic Animation Festival. Otherwise, everybody will think that I'm copying Spike and Mike!"

Throughout their careers, the only market analysis that Spike and Mike ever relied on was the pleasure that their audiences derived from the programming. The more people liked a something, the more Mellow Manor Productions tried to provide it. The success of that first evening of animated shorts made Spike and Mike speculate that if people wanted to see the old cartoons, maybe they might like to see new ones too.

At that point in history America had no traveling animation festival, and Spike and Mike sensed a hole in the market. In the late 1970s, independent animation had true believers all over the country, but if anybody wanted to attend a festival of new animated works they had few options. America needed an animation festival, but a place-specific event was too staid an idea for Spike and Mike, who were restless by nature. If they could not invite America to Mellow Manor, they would bring Mellow Manor to America.

Reasoning that two people armed with a film can full of cool cartoons, a 16mm projector, and an instinct for a good time might slip through that hole in the market and make a living, Spike and Mike began to seek out more independent animation.

Animators Marv Newland and Paul Dreissen were featured in the earliest festivals, and Spike and Mike also discovered a gold mine in the National Film Board of Canada, which had long been one of the world's hotspots for experimental animation. Animation legend Will Vinton allowed them to screen his Academy Award–winning *Closed Mondays* in their very first festival, which opened the door to the other A-list animators who were Vinton's predecessors and peers.

THE STRATEGY

Given that their business acumen was honed in greaser bars and Mellow Manor porn-a-thons, Spike and Mike's plan was fairly uncomplicated: assemble an evening of the best short animated films they could lay their hands on, splice them all onto a single 16mm reel, get a projector and hit the streets of the target city well in advance of the show to make contacts and

Spike flyering on a college campus

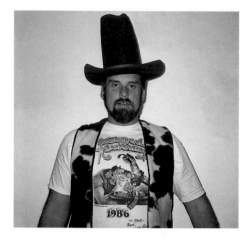

Wanted Dead or Alive: Spike

paper the town with flyers. Wherever and whenever possible, draw a crowd. Finally, make show nights such unbelievably fun events that their reputation will precede the show, even to the next town. Work locally at first and, as business increases, then go nationwide.

After all, the strategy had worked for Barnum and Bailey. It was pretty much the same plan they had used for promoting rock-and-roll events. How could anything possibly go wrong?

Of course, it was a hallmark of Spike and Mike's festivals that everything went wrong all the time, but that was just part of the charm. "Everything about the festival was always completely chaotic," says Marilyn Zornado, who first encountered Spike and Mike over the phone when she was working as a producer at Will Vinton Studios in Portland. "Spike would call to get films, and he would call three or four times a day. He had this big deep voice and would call me so many times to ask me the same

questions, I thought he was crazy. I asked Will about it, and he said, 'No, he's just a Really Big Guy,' as if that explained it."

"Then Mike started calling, and it was more fun to talk to Mike. I loved talking to him." (In fact, Mike and Zornado eventually fell in love. They were together until Mike's death in 1994.)

Spike and Mike's approach into a new city was more like storming a beachhead than a marketing strategy. They would arrive long before the screenings, sometimes a month or two in advance. Spike would get on the phone, and Mike would go to work making contacts to hire day labor for the flyering and the like. The auditorium would be booked, newspaper ads bought, and the grapevine shaken. Partying began, and flyers went out.

"We used to rent people's homes, furnished homes, in the different towns in advance of a festival. It would be our base of operations," remembers Shane Peterson, a member of the Mellow Manor entourage. "I remember Spike and Mike one summer struck a deal on the rent for a house in San Diego. We each have these canvas bank bags, with the zipper and the lock, filled with cash receipts from our previous festival. And we are pulling out cash and counting it in front of this woman, the homeowner. Spike looks up at her and she has this very curious look on her face—like 'Do I really want to rent my house to these people?' I mean, who could blame her. You look at Spike and you look at me, at the time, I had hair down to my ass—I looked like Slash from Guns and Roses. Spike looks at her and says, 'Uhh, we're not drug dealers or anything. We do business here

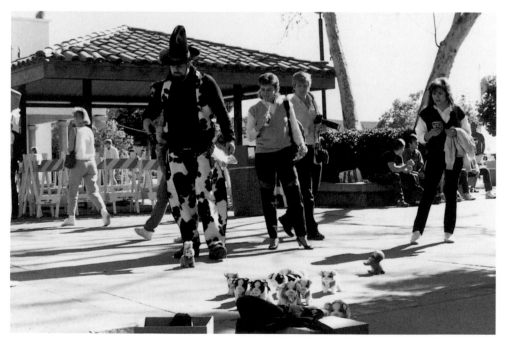

Spike as a cowboy drawing a crowd at San Diego University

in La Jolla—call the museum. They'll tell you we're legitimate businessmen.'"

It is interesting how many talented designers and artists have created Spike and Mike's famous flyers and posters over the years. Noted artists Bill Stout, Everett Peck, Robert Williams, John Pound, Moebius, Nick Park, Glen Barr, and many others have taken pride and had fun designing these now-collectible ephemera for Spike and Mike. It has been estimated that 10 million flyers have been passed around in the last twenty-five years.

The best advertising, of course, was always Spike and Mike themselves. They knew how to work those college towns. They would turn up at the local campus to let fly with antics, gags, and all manner of scandalous behavior. Imagine Spike at the bridge at Berkeley, dressed as Little Lord Fontleroy, waving a sledgehammer and threatening to batter a toy cow if passing coeds would not take a flyer. Imagine Mike standing behind a waist-high wall at Cal Poly San Luis Obispo, engaging passersby in conversations beginning with, "Hello, I'm not wearing any pants." Whether the passersby looked or talked or laughed or gasped, if they stopped at all they were forced to take a flyer. (P. T. Barnum used to say, "I don't care what you say about me, just so you spell my name right.")

One lifelong friend, Pixar animation director Andrew Stanton, recalls a typical stunt during one Spike's visits to CalArts. "I used to own a home in Valencia, nestled in a typical Southern California suburban neighborhood. Spike had picked up a cheap superhero costume, equipped with sequined hood, cape, and tights. He looked

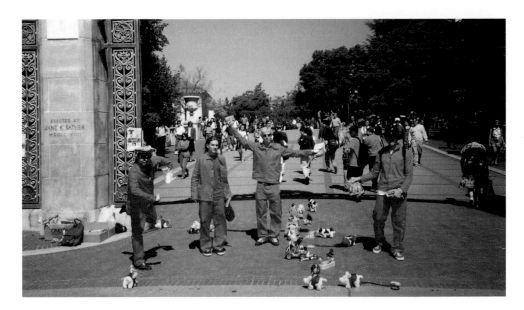

Flyering crew on the U.C. Berkeley campus. Frank Yahr (left) and Hugh Walton (third from left)

like the latest pro-wrestler creation in the WWF line-up.

"He came to my house dressed up in character with the rest of his 'carnie' crew, and had already given himself the name Centar. Apparently he had recently been distributing festival flyers at a nearby mini-mall and discovered his Centar persona was a kid-magnet.

"So he's over at my house, and we suddenly hear the local ice-cream truck. Spike bolts outside and approaches the throng of children getting ice cream. The kids are all slack-jawed, looking up at Spike as he towers over them and spreads his arms out wide to speak to his minions: 'Come get your ice cream, children! Centar is your friend! Defy authority!'

"Parents started grabbing their children and rushing them inside their homes, slamming the doors shut. One kid was being pulled back inside and waved back to Spike, 'Bye Centar, bye!' We had to get Spike back indoors before the cops came. That's how most Spike and Mike stories end, don't they?"

Spike and Mike enlisted a small army of friends, mostly Mellow Manor tenants, to help distribute flyers. Shane Peterson, Sean Reilly, and Jim Terry were the chief lieutenants. "I moved into the Mellow Manor in 1983," recalls Peterson. "The manor had eight bedrooms. Spike and Mike lived downstairs. It was an old Victorian house—huge. It had fireplaces in the den, upstairs, a pantry that by any standard would be a studio apart-

The beloved Scotty

ment nowadays. I was renting that out for fifty bucks a month and doing construction work part-time. Spike and Mike asked me if I wanted to make some money, go down to San Diego to pass out some flyers. I loved the idea of guerilla marketing, standing on a street corner and going through a couple of thousand people a day. It was a party."

On show nights, the real fun began. While the audience was still in line, Spike and Mike would work the crowd outside the theater; and once everyone was inside, they would entertain in the lobby. Then, in the auditorium, they would take the stage for more antics, introducing the independent animators—flown in for the occasion on Spike and Mike's nickel—whose films they were featuring. They would hold wacky contests, or let Spike's dog "Scotty the Shredding Wonder Dog," shred things onstage. Any crazy idea was fair game, anything that would whip the crowd into a good-time frenzy. Not since animation pioneer Winsor McCay played ball onstage to promote his proto-toon *Gertie the Dinosaur*

before live vaudeville audiences in the 1920s had animation been given such an introduction.

One night Jim Terry and Shane Peterson blew up some beach balls and threw them in the theater, "because we were running late," Shane remembers. "It was an easy way to pacify the people—but it caught on and became a trademark of the festival."

Working the road was not all fun and games, of course. Spike and Mike crammed impossible amounts of activities into each day. There were plenty of rough spots, and their arguments were explosive. However, there is no taking account of Spike and Mike's accomplishment without considering the fact that whenever the festival pulled out of a city, they left behind not mere ex-employees and fans, but friends.

Stanton recalls a typical Mike Gribble prank. "Mike had this ability to make himself sound like he could laugh uncontrollably. It sounded real. It sounded like somebody who lost it and couldn't contain it. I'd ask him to do it all the time in all these public places.

"We were at The Dish, a breakfast place in Haight-Ashbury, and a whole bunch of us from CalArts came up. We asked him, 'Do the laugh! Do the laugh!' He was always kind of tired when you asked him that, because he knew once he committed he was gonna fully commit, no matter what the ramifications in public were. He started to laugh and laugh and laugh. People started to look around, turn around, the Asian cashier guy started laughing. Pretty soon the whole place was cracking up. Then Mike really lost it—he spread this

jam on his toast, then stuck it to his head, on his bald pate, letting it slide down his face. He went into that insane mode. It looked like somebody just shot him in the head—all this jelly running down his face. We said, 'It looks like somebody shot you,' and he proceeded to lay down in the street and roll back and forth, shouting, 'Where's my wife, my wallet, it's gone!' Just to see what people would do.

"With Spike and Mike you were always guaranteed, within the hour, something like that would always happen."

THE FAMILY

The festival needed lots of labor, cheap, and the best way to get it was to hire locals. When the pair hit town, Mike would start canvassing colleges for young people interested in the festival and hire them for flyering and other work. Spike and Mike always fed their hired hands and, in fact, were renowned for family-style feasts at which everyone involved in the festival—Spike and Mike, the visiting animators, and the locals—all sat down together to eat. Like family.

Even in the early days when they could not afford to pay people in anything but baseball cards (Spike and Mike were avid card collectors), they always fed the help twice a day. These day laborers became friends, and Mike in particular made a point of looking them up whenever he was back in town—to rehire them, to deliver a gift that he had picked up on his travels or the latest festival t-shirt, or to just say hi. He earned a reputation for taking care of his own.

Animator Marv Newland (*Bambi Meets Godzilla*) was a longtime friend of the pair

and a regular guest animator. He remembers going to a fancy restaurant for one of Spike and Mike's post-festival feasts. "The maître d' was all in a tuxedo and the tables had pink tablecloths. There were maybe thirty of us, and it was quite, well, boisterous—people kept asking [animator Richard] Condie to do his famous scream. The maître d' was not impressed."

Zornado recalls one dinner at a restaurant that had a toy train running on a track around the room. "When the waiter wasn't looking, Spike would throw biscuits at it and try to hit it. Everyone in the place saw this, and they were included in the fun."

If there is anything to be learned from cartoons, it is that dessert is the most fun course. Newland recalls, "Spike was pushing the dessert cart around, in a fey voice asking everyone what they wanted for dessert." He adds, "The topper, though, was at Annecy one year: Spike spreading chocolate mousse all over his face with the help of John Lasseter."

COMPETITION

During the first leg of their new career on the road, Spike and Mike were in the blessed state of being essentially without any real competition in the United States. In the 1980s, however, Los Angeles–based promoter Terry Thoren compiled an anthology of animated shorts that he booked in a traditional way around the country, to repertory theaters and art houses, in direct competition with Spike and Mike.

Spike says of Thoren, "I thought he was trying to take what we had established

and polish it up and do it in the Hollywood manner." Which is exactly what Thoren was doing, of course. Bankrolled by Landmark Entertainment, Thoren's Expanded Entertainment was working the same market but with slicker, more Hollywood-style packages. For Spike, suddenly, it meant war. "It gave us motivation. It pissed me off and made me go for it."

One way to compete was to acquire the best films first. Spike and Mike traveled to international festivals looking for new work. When Thoren started showing up on that circuit, Mike took revenge in his own Animal House fashion, according to Zornado. Apparently Mike told everyone he met that this new guy Terry Thoren was throwing a great party up in his room at midnight, and everyone was invited. Bring your friends. (Thoren apparently rose to the occasion and, ironically, over the years went on to make a name for himself as a party host. Spike and Mike always took credit for getting him started.)

The heated competition created new opportunities for Spike and Mike's allies. "I flyered for Spike and Mike for three years, then after that I was coproducing the shows and scouting for films at Annecy and Zagreb," recalls Shane Peterson. "After five years I was looking to move on, but, at that time, Spike and Mike were looking to expand, so they approached Jim Terry and me to do more shows. They had the West Coast covered and wanted to push east. We basically sublicensed Irvine from them, and Spike and Mike got a percentage of the gross."

Terry sublicensed the Spike & Mike Festival in various cities such as Sacramento, Chicago, and Boston, retaining the "Spike

John Lasseter and Marv Newland

Mike and Danny Antonucci, as Terry Thoren looks on

& Mike" label. Peterson and Sean Reilly did the same in Toronto, Minneapolis, Washington, D.C., Madison, Wisconsin, and other cities under the trade names "Mellow Morons," "Multiple Maniacs," and ultimately "Shane & Sean."

Animation was still mostly underground as an industry, but it was beginning to peek out from under the manhole covers. Competition in the arts and entertainment may not feel good for the competitors, but

19

Spike, Angie Pike of the Creative Film Society, and Mike

it is good for the customers. Thoren's successes and Spike's new determination were generating interest in animation all over the United States and Canada, which was music to the ears—and eyes—of animators and fans everywhere.

IMPRESARIOS

Given the family feel of Spike and Mike's operation, it seemed natural that they would open their pockets when animators needed a few dollars for film processing or even more substantial sums to help complete an entire project. These were the days before computer animation, and, for an independent animator working in his basement, making a film was an even more expensive proposition than it is now. Film transfers are pricey, and Spike and Mike needed lots of transfers, not only from the artists' individual 16mm prints to the master show print but also from video and even Super 8. Spike and Mike took it upon themselves to help the animators with these costs whenever they could.

As the festival grew more successful, they decided to improve picture quality by switching from 16mm to 35mm, which of course increased costs. Although it is certain that it was in part a sense of largesse that encouraged Spike and Mike to help the animators, it also made good business sense, which was especially important once there was competition on the scene.

Given the increasing stakes, it also made good business sense to seek out the best animation at its source. Spike and Mike found their way to the places where lots of young animators could be found. California Institute of the Arts (CalArts), just north of Los Angeles, was a particularly fecund source of independent animation.

The CalArts film school's animation department was conceived by Walt Disney in the 1960s and, to this day, turns out more animation superstars than any other school in the United States. Here, Spike and Mike found a mother lode of talented, starving young animators, such as Andrew Stanton, Craig McCracken, and Rich Moore.

In some cases, Spike and Mike financed films outright. When festival audiences went crazy for Mike Judge's first *Beavis and Butt-head* film, Spike and Mike bankrolled him for more films. Production funding for McCracken's *Whoopass Stew* (which later became *The Powerpuff Girls*) was also underwritten by Spike and Mike.

By underwriting new films and the completion of films-in-process, Spike and Mike were helping to ensure the quality of their product. Plus, they also got dibs on exhibiting the best new films.

Since a film has to be in commercial release in order to be considered for the career-making Academy Award, many ani-

mated films were qualified for the Oscar by their inclusion in a Spike & Mike Festival, where most Oscar winners and nominees first saw the light of day.

Spike and Mike had now evolved into something more than promoters. By this point in their careers they were actually helping to resuscitate American animation, both as an art form and as a commercial enterprise. The two hippie holdouts from Riverside were now—amazingly enough—impresarios.

THE SHOW

The subversive, good-time spirit of animation had found its ideal proponents in Spike and Mike and their traveling show. Many elements contributed to the success of the festivals, such as the marketing. But any Spike & Mike fan will report that the real heart of the operation was always the show itself.

The Spike & Mike enterprise started out with only one festival, but as the market grew the operation bifurcated into two separate shows. One, the original Festival of Classic Animation, presents the finest world-class animation. Then there is the infamous and equally successful Festival of Sick & Twisted Animation.

"We started getting more and more [films] out of Vancouver, animators like Mike Grimshaw, and films like *Bambi Meets Godzilla*, *Lupo the Butcher*, films geared to a younger audience," says Spike. "I had to come up with a way to program those, and came up with 'Sick & Twisted.' We also did that because if it's '18 and over,' it intrigues

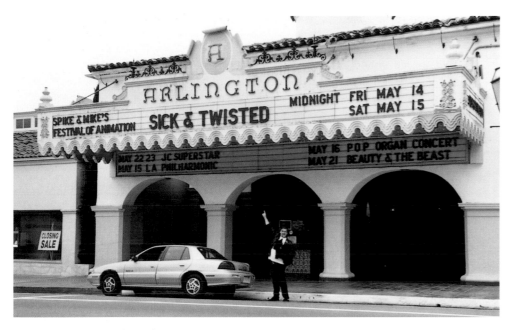

Spike at the Arlington Theater in Santa Barbara

Mike, Will Vinton, and Spike

would not be tolerated at 'her' movie theater. I find this quite ironic, firstly, because it comes from the Castro Theater in the heart of liberal San Francisco, and secondly, several days earlier at the same theater John Waters was signing asses on stage with Tammy Faye Baker."

people because it's something they can't have. Like a dirty book under the counter, you're gonna see it one way or another. That was a stroke of brilliance: My savant part came through for a little while."

No matter which festival people attended, however, they always got the Spike & Mike treatment. Whereas an evening at most animated film festivals is a pretty standard moviegoing affair, a Spike & Mike show feels more like a rock concert. First of all, there is an intangible buzz in the air, a palpable what's-going-to-happen-next quality. Fans and newcomers arrive expecting the unexpected. One never knows what strangeness will occur, even standing in line outside the theater.

For instance, on his birthday each year, Mike would show up at the theater having

spent hundreds of dollars at the local joke shop on toys, gags, and funny props. Everyone in line got a party hat, a noisemaker or two, and other toys. Inside, a net full of balloons that had been suspended over the audience spilled once everyone had taken their seats. Mike was fond of carrot cake, which was served to everyone at intermission. It was a party atmosphere from start to finish.

Once the lobby opened, Spike and Mike could be found there, playing golf or signing breasts. According to Spike, "The only theater we have ever been kicked out of is the Castro Theater in San Francisco. This occurred after the artist Coop and I were signing female body parts during intermission at the festival last year [2001]. The following day the manager called and lectured me on how this sort of behavior

Mike and Jon Minnis on stage

Mike, Spike, and Nick Park at the Academy Awards

Just like at a rock concert, memorabilia was on sale, but if you wanted to buy a t-shirt Spike and Mike had to throw it back and forth across the lobby a few times before you could have it. The Bad Tie Contest was a standard event. And once, wearing a fencing mask while swinging from the ceiling, Mike invited people to throw money at him. Every night was a free-for-all.

It was a standard feature of the festivals that once everybody entered the auditorium, giant beach balls were tossed into the crowd and paper airplanes were sailed, creating a summer-camp atmosphere. Then Mike took the stage. Audiences always looked forward to his opening monologue. He was just plain funny.

"On stage he had a great rapport with his audience. I was always amazed at how Mike could get in front of an audience and just move them," says Bob Kurtz, who was a special guest on several occasions. "He just had a ball up there, with half a mous-tache and half a goatee. And the audience moved him back."

Contests were held for prizes, and the latest inflatable sex dolls or whatever other strange thing they had come across in town would be featured. Toys and gifts were usually distributed to the audience. In Seattle, they once handed out five thousand free tubes of sex lubricant.

Audiences loved meeting the animators, and the animators loved being interviewed onstage. Over the years a number of now-legendary artists were part of the show, including Tim Burton, John Lasseter, Bill Plympton, Craig McCracken, Nick Park, Marv Newland, Mike Judge, Will Vinton, and many others.

Other special guests were trotted out at intermission and between shows, such as Weird Al Yankovic, Kato Kalin, Al Lewis ("Grampa Munster"), June Foray (voice of Bullwinkle's pal Rocky and other cartoon characters), and Jim Rose and his freaks.

THE ART OF CURATING

Spike and Mike's animation festivals were events. It is important to note, however, that their antics, pre-show warm-ups, and interactions with the crowd were not the most important part of the show. What ultimately set the festivals apart was Spike and Mike's taste in cartoons.

Although Spike and Mike had questionable tastes in many other areas of life, their instinct for cartoons was of the highest order. An evening at any other animation festival will always include a few duds, but at Spike & Mike shows it has been one great toon after another.

They traveled the world searching for animation and went to any festival, party, or event where animators could be found. "They were everywhere," says Bob Kurtz.

Curating a film festival, like curating a museum exhibition, is first of all a matter of patience. Spike and Mike were willing to wade through tons of crap to find the handful of pieces that finally made it into the festivals. They were intimate with all the sources of inspiration, for both the audience and the artists alike. As Danny Antonucci puts it, "That was Spike and Mike's whole thing: the people are always right."

They had to master the craft of assembling the shorts into a coherent package that represented each individual work well but

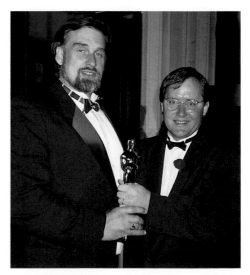

Spike and John Lasseter holding Lasseter's special achievement Oscar® for Toy Story, 1995

also took the audience on an evening's journey. They were aware of all the animation that was out in the world, everywhere. Lastly, they were able to anticipate trends, tastes, and interests. It's no coincidence that Spike and Mike had a consistent ability to predict which animated short would win the Academy Award each year. In animation, at least, their taste was impeccable.

MIKE

Late in 1993, Marilyn Zornado noticed that Mike seemed a little run-down. On the other hand, that was to be expected. "They were really busy," she said in an interview. "The amount of things that Mike tried to cram into a day was phenomenal. It was a very chaotic life they lived, and I thought he was run-down from that."

Mike's weariness seemed to drag on into the new year, however. According to Zornado, "We'd gone to Annecy and then we planned to go to Ottawa. Mike did the Portland show and was kind of run-down, but nothing specific. I made him go to the doctor. Then the show moved down to La Jolla and he still wasn't feeling well, and the doctor gave him a test. He had hepatitis.

"He went for more tests. It wasn't the hepatitis that was causing the problems, it was a blockage in the bile ducts, so he had surgery. It was a very long surgery, and they found out he had cancer in the pancreas and that it was spreading. The doctor had said it was unusual for someone Mike's age to get [pancreatic cancer], because it was a cancer of old people."

Zornado was working at Will Vinton Studios in Portland and flying down to La

Jolla whenever she could to care for Mike and drive him to chemotherapy.

She was in Portland on the day of his final treatment. "It was his last week of chemotherapy and he was going to come to Portland to recover. I talked to him on the phone. He still didn't even think about slowing down.

"He had a heart attack during the chemotherapy." That was August of 1994. Mike Gribble was forty-two when he died.

There may be lots of "Mikes" in the world, but for those who knew Mike Gribble, he remains the one and only. There are countless tales told and retold of his outrageous pranks, behavior, and lifestyle. He was an entertainer, an iconoclast, and an enigma.

For instance, Mike was a talented golfer who played the game with passion and his own characteristic flair. Animator Bill Plympton once invited Mike to play with his father, who belonged to a private club in Portland. Mike showed up in a purple beard, half of a moustache, and his usual mismatched clothes.

Another story is told from Mike's early days in Riverside, when a friend invited him to play with him and his father at the local upscale golf club, where the father was a member. The friend and his father had to pick up Mike at his home, however, which at the time was a cardboard box. Mike went on to impress everyone with his skill on the course.

His generosity and thoughtfulness were renowned. "Mike was always shopping for everybody," says Zornado. "He was always buying

Marilyn Zornado and Mike

gifts for people. He was the most generous person I've ever known." His showmanship extended to his private relationships too, and for Zornado's fortieth birthday he really went all-out.

"He flew to Portland and brought me a big present at the office. Then at five o'clock a Rolls-Royce arrived and we got in and went downtown to my favorite bar, and fifteen of my friends were there. Then all of a sudden everybody had to go somewhere. It was just my friend Fay and I, and Joanna Preistley and Mike. We went outside and there was a stretch limo. We got inside and went across town to a little theater that he had rented, and a hundred of my friends were there. It was this huge surprise party. There was a marimba band, and we danced all night."

Libby Simon recalls one dinner at a posh eatery when Mike—a wine connoisseur—ordered the finest wine on the menu. Apparently the sommelier leaned over to

Spike and his entourage, Mary Lai
"Petite Cleavage" Heidenrrich and
Rosie "The Riveter" Turner, in San
Francisco's Haight Ashbury District

the fellow in the shocking pink jacket, half a moustache, and purple hair to let him know that the wine was very expensive. "And Mike said, 'Then I definitely want it!' He was always astounding," she says.

Mike Gribble's loved ones held simultaneous memorials for him in New York, London, San Francisco, Ottawa, Toronto, and La Jolla. His old competitor, Terry Thoren, organized a service in Malibu.

Mike's closest loved ones were at the La Jolla service. "Everyone wore purple," Zornado recalls. "Mike's mother had an Episcopalian minister do a service. People spoke, and I read a poem. A friend from a band in Riverside played, and then we released a giant purple weather balloon.

"We had taken Mike's collected watches and wind-up toys and put them in bags, and we handed them out. Everyone got one."

No doubt Mike would have loved the final salute, given his passion for golf: twenty-one of his guests were given golf clubs and invited to hit balls into the ocean.

As it turned out, the party was not over. Each year at the Annecy Festival in France, Mike would take a crowd of friends out to a four-hour luncheon at a fabulously expensive restaurant, where he always picked up the tab. Toward the end of his life, when he realized that he was seriously ill, he told Zornado that after his death she was to clean out a Swiss bank account that he kept specifically to pay for the Annecy luncheon. After Mike's passing, Zornado went to Zurich, got the money, and held the luncheon as instructed, with all Mike's friends present. Marv Newland wore Mike's famous shocking pink jacket.

THE SHOW GOES ON

Spike continues to produce a new Classic Festival and a Sick & Twisted Festival each year. The festivals are still a benchmark of quality in animation, and Spike has a great sense of pride in what he and Mike accomplished together. "We invested twenty-three years in this," he says. "That's something in this damned world."

He carries on, determined to bring new audiences and greater recognition to animation. Within the last five years Spike has gotten the Sick & Twisted Festival screened at prestigious international film venues (Sundance, Slam Dance, Cannes, and, most appropriately, Annecy), as part of a rock concert tour across America (with Korn), and on the Internet (ifilm.com).

"The greatest joy in doing what I do is fulfilling my desire to avoid being part of the rat race, to not have to wear a suit and get up early," Spike says. Away from his full-time duties with Mellow Manor, Spike likes to relax with his hobbies, which include "doing Yoga, collecting antique

Spike at the Sundance Film Festival in 2001. Photograph by Roger Ebert

Holmes Walton and Scott "Haireball" Haire, closing night at the Crest Theater in Sacramento, December 7, 2002. More than ten thousand people attended the show during its run.

guns, donating time and money to animal rights groups, and being a connoisseur of lingerie."

In the same way that "underground" FM stations of the 1960s and early 1970s have now become the norm, so it is with animation, much thanks to Spike and Mike. Up from the ashes of what had been the animation industry of the 1930s, '40s and '50s, they coaxed and encouraged some of the greatest talents of the twentieth century. Inviting the world to join them, they celebrated animation and made of themselves a stepping stone for the industry's current revival.

Before Spike and Mike, says Kurtz, "There was this feeling of animation being a stepchild to the film business, or that it was just a babysitter for children. But these two guys got the public there, they pulled them in off the street—anybody who wanted to see a good show—and showed them animation."

Sean Reilly says, "They brought a greater awareness to animation. They made the public understand that it wasn't a static art form that ended with Warner Bros. and Bugs Bunny cartoons. Also, they gave animators an avenue for making a couple of dollars, and it got the films recognized."

Although the Spike & Mike Festival cannot be credited with single-handedly creating the current animation revival, it is simply a fact that major animated shows like *The Powerpuff Girls, Beavis and Butt-head,* and *South Park* might not have existed had it not been for the vision and commitment of Spike Decker and Mike Gribble. Independent animators across America continue to be influenced in countless ways by the work that Spike and Mike encouraged and made (and still make) available.

Networks like Fox, MTV, Comedy Central, and the Cartoon Network have developed extraordinary creator-driven animated shows during the last ten years, but it was Spike and Mike's efforts that initially brought these talents to public attention.

The Festival of Animation proved, without a doubt, that the art form could be adult, that animation was fun, and that animators were cool.

In a sense you could say that the real achievement of Spike and Mike was that they knew how to have a good time. They loved animation and the wonder and delight it gives people.

Marilyn Zornado: "Spike was big, and Mike was crazy, and you never knew what they would do. They would have huge fights, but they were the funniest people ever when they were on."

They loved life, and they shared that love with their audiences through animation. "No one did it better than them."

Spike at the Annecy Festival in 2002

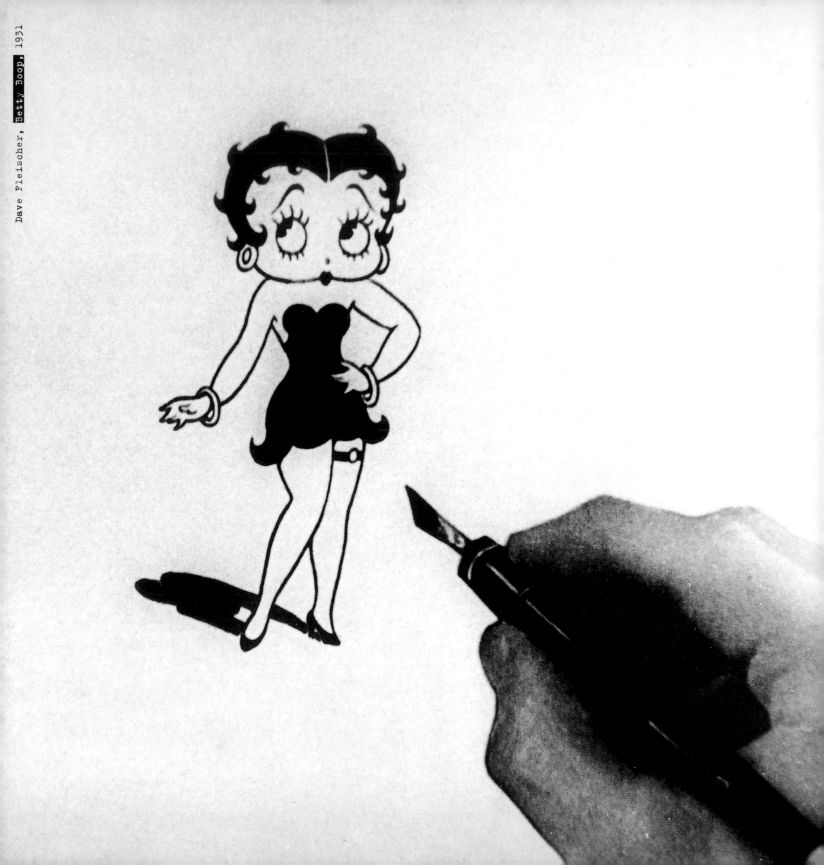

The Roots of
Outlaw Animation

Before there was a Spike & Mike Festival, and long before there was a Bugs Bunny or a Mickey Mouse—back in the earliest days of film history—the animated cartoon was born.

The novelty of motion-picture photography, since its creation by the Lumière Brothers of France in 1895, had inspired film pioneers worldwide to create fantastic images and visions impossible to stage in real life. Early trick-film creators, independent artists consisting of magicians, cartoonists, and puppeteers, experimented with the new medium and found that early moviegoers were thrilled by moving line drawings—animated cartoons that defied logic and lampooned authority.

The first American to animate a cartoon, J. Stuart Blackton, morphed a chalk drawing of a man into various ethnic stereotypes to provoke humor from identifiable caricatures. Seen today, *Humourous Phases of Funny Faces* (1906) is even more politically incorrect than an average episode of *South Park*. Experimentation and shock humor were part of animation's history from the very beginning.

Cartoonist Winsor McCay established the animated cartoon as a theatrical attraction with his *Gertie the Dinosaur* (1914), first exhibited as part of his quick-sketch vaudeville act, then widely released as a short subject. Audiences marveled at a new kind of cartoon character, a drawn figure that not only moved but had a personality, expressed emotion, and could communicate directly to the theater audience.

Within the next few years a full-fledged animation industry was established, based mainly in New York City, churning out a string of forgettable comic-strip spin-offs (Mutt & Jeff and Krazy Kat were the cartoon movie stars of the silent-film days). A factory-like studio system was quickly created to fill the demand for animated cartoon comedies.

Certain cartoonists emerged as animation pioneers—prolific Paul Terry with his *Aesop's Fables* spoofs, inventive Max Fleischer and his combination live and animated Koko the Clown, as well as young Walter Lantz, Walt Disney, and Pat Sullivan, who had a big hit with *Felix the Cat*. But none of these men produced their animated films alone. Each created studios to mass produce cartoons for the major film distribution companies.

By the 1920s animation was not something the average cartoonist would tackle without support. Stories of Winsor McCay's four-year effort to draw every frame of *Gertie the Dinosaur*, and reports of the time-consuming and costly process of studio-produced animation left most independent cartoon artists with something to say sticking to their comic strips and editorial cartoons.

By the time Mickey Mouse uttered his first words (in *Steamboat Willie* of 1928), animation was a mass medium and a business. The independent animator who had founded the art form was essentially a nonentity, with the exception of a few experimental artists who dazzled high-brow museum types with their non-narrative avant-garde films.

Innovation in the 1930s was led by the popular Hollywood-backed studios. Walt Disney ruled the day, and his standard of quality was thought to be the benchmark of what a cartoon could, and should, be. But Disney's technical and artistic development served only to meet his particular goals: to retell classic fairy tales, to achieve realism in character animation, and to popularize a menagerie of happy-go-lucky, clean-cut cartoon stars.

Most of Disney's competitors gladly followed his lead, but a few challenged Uncle Walt by concentrating on an area his films fell short on—humor. The Fleischer Studio in New York (and later Miami) found success with the outrageous sexual antics of Betty Boop, created by producer Max Fleischer and directed by his brother Dave. Surreal cartoons such as *Snow White* (in which Betty is tormented by the

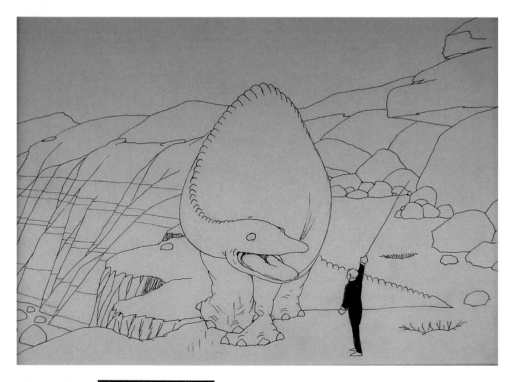

Winsor McCay, Gertie the Dinosaur, 1914

booze-guzzling ghost of Cab Calloway) and *Boop-Oop-a-Doop* (1933, where Betty is chased around the circus by a lecherous ringmaster) became more popular than Mickey Mouse's wholesome barnyard antics.

The Fleischers took on Disney in a number of other ways too: competing with a pair of feature-length films (most notably 1939's *Gulliver's Travels*), innovating cartoons with multidimensional animated backdrops, and producing a series of ambitious, noncomic adventures of *Superman* (1941).

In 1934 Hollywood adopted the Hays Code, a self-inflicted set of guidelines, in an effort to clean up the movie industry's questionable reputation. It placed new restrictions on film content, forcing the racy Betty Boop to also clean up her act. The Fleischer Studio had just introduced *Popeye the Sailor* (based on a popular comic strip), whose all-American violence was less of a threat to family values.

The Warner Bros. cartoons, produced by Leon Schlesinger, emerged in the late 1930s with their own brand of wacky cartoon humor. The Porky Pig *Looney Tunes*, directed by Tex Avery and Bob Clampett, set the stage for an alternative to Disney's roster of cuddly stars. Stuttering pigs, insane ducks, and wise-guy rabbits—in other words, characters the audience could relate to—soon ruled the animation roost.

By 1940 a full-scale animation golden age was in flower. Bugs Bunny, Woody Woodpecker, and Tom & Jerry were born during that year. Every Hollywood distributor owned an animation studio or had an affiliation with one. The animated cartoon

Dave Fleischer, Betty Boop, 1932

short was an expected part of every movie program. With the quality of craftsmanship at an all-time high, a status quo was achieved.

It was during the years of World War II that the first hints of new thinking emerged, as independent animators with styles of their own countered Disney's influence. The National Film Board of Canada was established in 1939 as a government-sponsored agency commissioned to make films about the Great White North and patriotic propaganda to aid in the war effort. Norman McLaren joined the NFB in 1941, creating a filmmaking unit that would experiment with, and pioneer, new and different animation techniques. McLaren won acclaim for his short films made by drawing directly on strips of 35mm film or by scratching images into the emulsion. McLaren won an Academy Award (Best Documentary Short) for his pixilation (stop-frame animation of live actors) film *Neighbors* in 1952—the first non-Hollywood animated ever to win an Oscar.

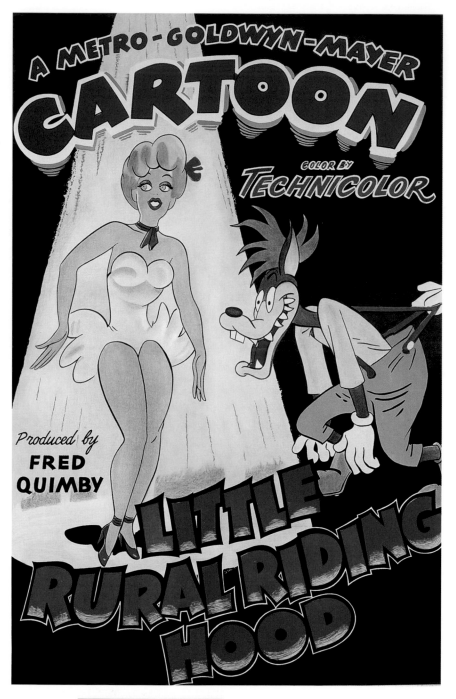

Tex Avery, Little Rural Riding Hood, 1949

Anti-Disney stylization took hold of some forward-thinking animators in the United States. A small band of Disney renegades cut loose and started the Industrial Film and Poster Service to produce highly stylized, low-budget animated films for clients such as the U.S. Air Force, the United Auto Workers, and any commercial client they could muster. A 1948 contract to provide Columbia Pictures with theatrical shorts propelled this small studio to greatness. Renamed United Productions of America (UPA), and led creatively in the earliest days by John Hubley, this studio run by artists defied the traditional Hollywood cartoon shorts of the day with bold, modern graphics and adult storylines.

By the early 1950s UPA won critical kudos for films such as Hubley's *Rooty Toot Toot* (1952, the "Frankie & Johnny" story set to music), a gothic retelling of Edgar Allen Poe's *The Tell-Tale Heart* (1953), and James Thurber's witty *The Unicorn in the Garden* (1953); and the studio copped an Oscar for an innovative adaptation of Dr. Suess's *Gerald McBoing Boing* (1950).

UPA's lower budgets forced them to become creative about *limited animation*. This form, which became associated with cheap television cartoons later on, was initially utilized by UPA to create innovative artistic, story-driven, animated works that visually relied more on art direction than flowing movement. Hollywood, of course, picked up these money-saving short-cut techniques (held poses, simplified character design, abstract backgrounds). But more importantly, animators around the world picked up on UPA's creator-driven approach.

That inspiration was particularly influential in Europe, where studios in Yugoslavia, Italy, Hungary, and Russia emerged and produced highly artistic and personal films. An animated-film society, ASIFA (Association Internationale du Film d'Animation), was formed in 1958, bringing together the worldwide animation community. By the late 1950s biennial international animated-film festivals, sponsored by ASIFA, began in Annecy, France, and Zagreb, Yugoslavia. Major festivals in Ottawa and Hiroshima would join the ranks in later decades. An audience was now established for animated art films—albeit a small one, mainly situated in Europe.

The festivals were taken seriously by the film community. Even Hollywood was swayed by the array of important independent international talent—talent that could not be denied. In 1958 a typical Hollywood-produced Bugs Bunny cartoon (and not a particularly good one at that) won the Academy Award for Best Animated Short. As the sixties approached, however, the Academy could not ignore the new wave. The 1959 Animated Short Oscar went to John Hubley's independent film *Moonbird*; the 1960 award went to American Gene Dietch's independent *Munro* (animated in Prague); and 1961's honor was bestowed on Zagreb's *Ersatz*.

This exposure meant theatrical exhibition in the United States for the prizewinners. Even the American public of the early 1960s, firmly entrenched with traditional Disney feature fare and welcoming a new wave of Hanna-Barbera TV cartoons *(Yogi Bear* and *The Flinstones)*, was becoming aware of artier animation films. So preva-

lent were these films that Mel Brooks spoofed the trend in his own Oscar-winning short *The Critic* (1963, directed by Ernest Pintoff).

The late 1960s youth culture showed an extreme interest in these offbeat, adult-oriented films. ASIFA established a *tournée* of animation, a traveling festival road show of the best international and independent works, but its exhibition in the United States was limited to staid museums and snooty art-house venues. Colleges began offering filmmaking courses with access to affordable 8mm film and camera equipment. Independent animation was being shown in college classrooms and at campus film societies, and producing animation was widely encouraged among young people.

A nostalgia boom revived many forgotten, now high-camp, animated cartoons from the 1930s, such as Fleischer's *Betty Boop* and Van Bueren Studios' trippy *The Sunshine Makers* (1935), which were regularly shown at rock concerts and wildly enjoyed by the stoned-out crowds. Contemporary cartoons, such as *Thank You Masked Man* (1968, based on a Lenny Bruce soundtrack) by John Magnuson and Jeff Hale and *Bambi Meets Godzilla* (1969) by Marv Newland, became cult classics of alternative animation.

As an industry, animation in the United States and worldwide suffered a recession during the 1970s and 1980s. The traditional theatrical distribution of studio cartoons came to an end, leaving Hollywood's surviving cartoonists to churn out low-budget Saturday morning kiddie TV shows. An era had passed. But baby boomers, raised on a

steady diet of classic animation and learning the filmmaking techniques in school, were preparing to take the art form to the next level. And some of them, influenced by the more racy, raunchy, and raucous cartoons of the past, would come to define the "sick & twisted" genre.

Animation was always subversive.

The first animation studios, back in the silent days and early sound years, filled their films with plenty of mainstream mischief: slapstick violence, over-the-top racial humor, and sexual innuendo. Oh yes, that Felix the Cat was quite the bad boy.

Pre–Hays Code Hollywood embodied the attitude of "anything goes"—and everything went. Pat Sullivan's feline Felix and Paul Terry's Farmer Al Falfa regularly drank booze; Fleischer's Betty Boop flashed her "boops"; Disney's Minnie Mouse frequently lost her bloomers; and Ub Iwerks's Flip the Frog flipped his middle finger at pesky opponents. In one of his first screen appearances, Mickey Mouse made music tickling a mama sow's teats (a notorious sequence now censored from *Steamboat Willie*, 1928)—but that was mild compared to Everyready Harton.

The most outrageously "sick & twisted" cartoon to be created during the early days of animation was *Everyready Harton in Buried Treasure*. The film was the animated equivalent of a "Tijuana Bible" (those little underground eight-page porno comics popular in the 1920s that placed well-known comic-strip stars in coital positions). *Buried Treasure*, a six-minute

hard-core masterpiece, was produced "under the light box" by the New York animation community. Rumor has it that the film premiered at a tribute dinner for Winsor McCay in the late 1920s to show the pioneering animator how his precious invention of moving drawings had been perverted by the industry.

Most of one-joke *Buried Treasure* has its protagonist repeatedly pleasured by all manner of women and farm animals. At one point he sticks his erect member through a knothole in a fence, in belief that a lovely damsel on the other side will please his desires. After a few minutes of ecstasy, Everyready discovers his passionate lover to be but a hungry cow.

In contrast to so many lost films of the silent era, *Buried Treasure* has been lovingly preserved. For all its crudeness, the film was clearly the skilled work of professional animators. It would be the last of its kind until Ralph Bakshi introduced *Fritz the Cat* in the 1970s.

The few scant attempts at X-rated animation in the intervening forty years would be by solo amateurs. Animated porn was not as profitable as its live-action counterpart and the effort involved to create it was not worth the trouble. Though rumors still exist about a secret X-rated reel of Disney's *Snow White and the Seven Dwarfs* (1937), which the animators supposedly created in their off hours, the truth is that it never happened. There were never "off hours" on large-scale Disney productions like *Snow White*.

But the existence of *Buried Treasure* has fueled the fantasies of cartoon buffs and

"sick & twisted" animators, not to mention a few animation historians, for decades. That is not to say animators did not draw plenty of dirty pictures to post up at the studio. World War II brought the pin-up girl to popularity, and Hollywood animators did its bit for the war effort by making salacious pin-up drawings and gag cartoons exclusively for the American soldier. The Motion Picture Screen Cartoonists Union (in a joke book called *Service Rib-bin'*) and Walt Disney Productions (through a wartime publication, *Dispatch from Disney*) sent our servicemen a morale—and libido—booster via a variety of girlie-gag illustrations.

The only hint of animated sex during the golden age of Hollywood cartoons was found in Tex Avery's *Red Hot Riding Hood* (MGM, 1942). Animated by Preston Blair, Avery's sexy bombshell—the inspiration for Jessica Rabbit in *Who Framed Roger Rabbit* (1988)—became a World War II sensation. Appearing in just seven cartoons between 1942 and 1949, sexy Red was in keeping with Avery's usual warped sense of humor, twisting a classic fairy tale by turning the innocent Little Red Riding Hood into an experienced bombshell.

Red was so hot that MGM personnel would steal her animation cels before they were even shot and committed to film. (Cels in those days were routinely thrown away or cleaned off for reuse, and not the collectibles they are today.) But as sexy as Red was, it was the wolf's howling reaction shots that supplied the actual innuendo. His bulging eyes, erect body, and exploding energy represented male sexual desire in an abstract, yet entirely literal, sensual overload.

After the war, Hollywood cartoons essentially went back to the playground. And while UPA and a few others tackled adult problems and foibles, sex was essentially banished from the cartoon kingdom.

That is, of course, until *Fritz the Cat*.

By the late 1960s, the idea of sexual angst among cartoon characters was largely forgotten, and the whole notion of animation aimed at adults was abandoned. Animation was no longer used for topical humor or social commentary. Cartoons were perceived as strictly for kids.

The kids, however, had embraced the subversive side of classic cartoons. The baby boomers of the hippie generation could identify with the anarchic heroics of Bugs Bunny and the sexually liberated Betty Boop in animation created twenty to thirty years earlier. The new generation soon created their own cartoon stars: the most popular to emerge was Robert Crumb's anti-hero Fritz the Cat.

Enter Ralph Bakshi, in his late twenties by the mid-1960s, already a veteran of the old-school Terrytoon factory (where he started in his teens during the 1950s), having risen through the ranks from inker and painter to become a supervising director by 1966. A devotee of E. C. Comics, J. R. R. Tolkien, and underground cartoonists, Bakshi decided that adapting Crumb's Fritz to the big screen, as an X-rated animated feature no less, was where animation should go next.

Tex Avery, *Red Hot Riding Hood,* 1943

Robert Cannon, Gerald McBoing Boing, 1950

He was clearly in touch with his audience, mainly college students, who could relate to cartoon characters that cursed, screwed, and drew blood. All those attributes were contained in *Fritz the Cat* (in production from 1969 through 1971 and released in 1972), which, despite its crude elements, was embraced by critics who recognized that this was no quickie sexploitation flick but a serious film reflecting the voice of the current youth movement.

Bakshi became the "Disney" of adult-skewed animated features during the 1970s, momentarily changing the "animation is for kids" perception. An occasional X-rated animated feature (Chuck Swenson's *Dirty Duck* in 1977 for one) and a few sexy animated shorts were produced—with world-class animators like Bruno Bozzetto of Italy and Osamu Tezuka in Japan leading the way–but there was no real market for such films outside of the few international animation festivals.

While sexual themes in animated cartoons were few and far between, American animators always excelled at violent action. Exaggerated cartoon slapstick (in another word, violence) has become a trademark of the Hollywood cartoon. Inspired by the zany antics of flesh-and-blood screen comedians such as Harold Lloyd, Buster Keaton, and the Three Stooges, animators could top the wild chases and impossible stunts, magnify emotions, and stretch limbs with ease. They gave real meaning to the famous expression, "The pen is mightier than the sword."

Though animated violence can be dated back to the earliest silent cartoons of World War I, it was during the sound era that cartoon stars were born and tied

directly to violent mayhem. There was Popeye, who would take a beating and then return it tenfold after eating a can of spinach; and Tom & Jerry, the cat-and-mouse duo, who would skin each other alive on a regular basis. The more violent, the more popular: Bugs Bunny, Woody Woodpecker, Heckle & Jeckle, the Road Runner, Wile E. Coyote, and dozens of others got into the act. The giant mallets, the sticks of dynamite, the flying axes, the falling anvils, the black, round cartoon bombs, the endless explosions—all the props and standard situations of Hollywood cartoons that have become so common and clichéd are fused in our minds as conventions of animation.

This trend continued into the TV series of the 1950s and '60s (with violent superhero cartoons and the like), but subsided during the movement to refocus animation strictly on kids' programming. The gradual suppression of such violent cartoon images made it all the more shocking thirty years later when *The Simpsons'* "Itchy & Scratchy," and the kids of *South Park* began appearing regularly on television.

Most of the classic "Sick & Twisted" shorts are violence-based: *Lupo the Butcher*, *Beavis & Butt-head in Frog Baseball*, *The Dirdy Birdy*, and *Bambi Meets Godzilla*, to name but a few. Modern animators exaggerate the violence much further than their predecessors, but there is a clear and direct lineage to the pioneering, subversive animation of Chuck Jones and Tex Avery.

One outrageous trait of cartoon history has yet to reemerge successfully, and perhaps that is for the best. Racist humor—making fun of a character based on nationality, race, or religion—has essentially stopped,

considered too politically incorrect even for the most radical animator today.

Seeing a racist 1930s cartoon, particularly with titles such as *Pickininny Blues* (Van Bueren/RKO, 1932) or *Uncle Tom's Bungalow* (Warner Bros., 1936), can be quite a shock to a young person raised on a diet of the Smurfs and Scooby-Doo. Chinese, Jews, Italians, Native Americans, and particularly Blacks were grotesquely caricatured and lampooned. One cartoon, Bob Clampett's *Coal Black and De Sebben Dwarfs* (Warner Bros., 1942) is a brilliant spoof of Disney's *Snow White and the Seven Dwarfs* (1937). Though well made, and featuring a black voice cast (all in on the joke), this cartoon features broad stereotypes such as an "Aunt Jemima" like evil queen, a pimplike "Prince Chawmin'," and a sexpot "So White." The Dwarfs run "Murder Incorporated" (a sign on their truck reads "We rub out anybody $1.00—Midgets: 1/2 price—Japs: Free!"), and it is implied that So White has slept with all of them to save her life.

During World War II, the Japanese were raked through the coals in propagandistic cartoons like *Bugs Bunny Nips the Nips* (1944) and *You're a Sap, Mr. Jap* (1942, with Popeye). Hollywood cartoonists created the savage caricature of a pint-sized, buck-toothed, knife-wielding yellow terrorist, fanning the country's hatred of the enemy. Dozens of anti-Japanese cartoons were produced in the wake of Pearl Harbor. Typical was *Tokio Jokio* (1943 Warner Bros.), a parody that supposes to be a captured Japanese newsreel that features news items such as the demonstration of Japan's "Finest Air Raid Siren": a screaming Japanese soldier getting pins stuck in his rear.

America's consciousness was raised after the war. The racial stereotype was largely abandoned, slowly but surely, during the civil rights movement of the 1950s and '60s.

Ever the bad boy, Ralph Bakshi tackled racism in his third animated feature film *Coonskin* (re-released and retitled *Street Fight*, 1975). Bakshi intended to ridicule the ancient stereotypes, but by portraying his lead black characters in the classic thick-lipped cartoon caricature, he caught flack from the N.A.A.C.P. and lost his original distributor (Paramount, though the film was later released independently). Threatened and booed off the stage during a preview screening at the Museum of Modern Art, Bakshi learned the hard way that an era had ended. An occasional gay stereotype on *South Park* or an internet cartoon such as *Mr. Wong* (starring a stereotypical Asian character) are rare examples of this sort of humor applied today.

Sex, violence, and racism are nothing new to animation. They've made audiences laugh for decades. Cartoons with these themes have also stimulated, provoked, and enraged. How viewers react to these works depends upon the ultimate presentation. For the last two decades, Spike & Mike have created a modern venue for "Sick & Twisted" animation to flourish: freedom of expression in its purest, rawest form—and strictly for laughs.

Ralph Bakshi, Fritz the Cat, 1972

Gallery of Independent Animators

The following is a sampling of some of the field's more important figures, all of whom have been represented in the Spike & Mike Festivals. Each artist (or studio) has a unique point of view and has perfected a distinct individual style. There is only room here to describe the careers and work of a fraction of the great artists who have defined the independent animation movement.

FRÉDÉRIC BACK

A two-time Oscar winner (for *Crac!* in 1981 and *The Man Who Planted Trees* in 1987), Frédéric Back uses illustration-style animation to imbue characters with vibrancy, and his moving-camera technique lends urgency and excitement. Like those of Caroline Leaf (see page 45), his films are meticulously crafted. *The Man Who Planted Trees*, for instance, took five years to make. Back draws directly onto cels with colored pencils dipped in turpentine.

In Back's films, the dancing camera draws the viewer inside the frame, delighting the eye and mind and touching the heart. These films are always charming to watch.

Back was employed by Radio Canada, which for a time produced animation. Animators like Leaf, Paul Driessen (see page 43), and Back create pure expressions of the independent spirit. Although their films have the professional polish of studio films, works like these could never come out of an assembly-line system.

Frédéric Back, The Man Who Planted Trees, 1987

BRUNO BOZZETTO

Bozzetto burst into prominence with his
1976 hit feature *Allegro Non Troppo*.
Although this remarkable film is a parody
of Disney's *Fantasia*, it stands on its own
as a great work of animation. The film is
humorous, wildly imaginative, and artisti-
cally bold.

Born in Milan in 1938, Bozzetto has created
dozens of shorts and a number of features.
His *Mad Magazine*–like style is well
known among fans of independent anima-
tion worldwide, and his craftsmanship is
highly regarded. The sharp humor and
sometimes bawdy subject matter that suf-
fuse his films clearly signal adult sensibil-
ities, but with a childlike passion for fun
and artistry. Bozzetto's work is easily as
funny as Tex Avery's finest cartoons, but its
visual beauty surpasses even that of the
great American master.

Bruno Bozzetto, Allegro Non Troppo, 1976

Bruno Bozzetto, Grasshoppers, 1990

Bruno Bozzetto, Allegro Non Troppo, 1976

SALLY CRUIKSHANK

In the late 1960s the influence of 1930s surrealism flowered in the work of independent animators like Sally Cruikshank, inspiring films that not only reflected inner landscapes and more timeless themes but also thumbed their noses at established traditions. From the moment that she burst onto the alternative scene with *Quasi at the Quackadero* (1975), Cruikshank has been associated with San Francisco's wonderfully heretical spirit.

Over the years Cruikshank has flourished, although she remains somewhat under the radar in terms of publicity. Her character Quasi has starred in a number of films that command a loyal following. Cruikshank, using tried-and-true cel-cartooning techniques, has made a number of television commercials and titles for at least one live-action feature. Her influence on the younger generation of women animators, and on independent animation in general, is great. During the 1970s when the field was trying redefine itself, Cruikshank's work was a wonderful reminder that cartoons are a celebration of ideas born at the furthest reaches of the imagination. Like many great artists, she makes the difficult look simple and complex ideas seem obvious. Without a doubt, she has helped to keep alive the sense of delight that is so integral to independent animation.

Sally Cruikshank, Anijam, 1984

Sally Cruikshank, Quasi's Cabaret Trailer, 1980

Sally Cruikshank, Quasi at the Quackadero, 1975

Sally Cruikshank,
Quasi at the
Quackadero
(poster), 1975

MICHAEL DUDOCK DE WIT

Although he is Dutch, Michael Dudock de Wit has been a resident of England for many years, where he has a reputation as an educator, illustrator, and, like so many independent animators, a maker of outstanding television commercials. Beyond these ventures, however, de Wit's animated films are becoming the stuff of legend.

De Wit's drawing style employs the fewest lines possible to create the most emotional impact, almost in the spare tradition of the Dutch masters. His characters move in a way that invariably evokes empathy, and we find ourselves intimately involved with them even when we cannot see their faces or hear them utter a word of dialogue.

An Oscar winner for *Father and Daughter* (2000), de Wit is also known for *The Monk and the Fish* (1994), equally esteemed as powerful and joyous animation. With a draftsman's skill and an artist's insight, de Wit moves his characters physically in a way that moves us emotionally.

Michael Dudock de Wit, Father and Daughter, 2000

Michael Dudock de Wit, The Monk and the Fish, 1994

PAUL DRieSSeN

Even in an art form where each work is its own universe, Driessen's films stand out for their eccentric, weird logic and indescribable style. Born in Holland in 1940, Driessen worked on The Beatles' *Yellow Submarine* (1968). In the 1970s and '80s, when independent animation went through a phase of taking itself very seriously, Driessen's cartoons were some of the more lighthearted.

Unlike much of the underground work, Driessen's animated films look like traditional hand-drawn cartoons, which may explain their ability to draw us into an unexpectedly weird world. His deceptively simple, squiggly-line technique has been imitated, but never matched, because it requires such masterful draftsmanship. His are odd, remarkable little films, which in lesser hands would be a mess.

Nurtured at the National Film Board of Canada, Driessen nonetheless has made the largest percentage of his films in Holland. Some of his well-known works include *The Killing of an Egg* (1977), *David* (1977), and *Elbowing* (1979).

Paul Driessen, The Waterpeople, 1992

Paul Driessen, Elbowing, 1979

Paul Driessen, Three Misses, 1999

BOB GODFREY

Although he is known as an English animator, Godfrey was born in Australia; he received his education in England, where he formed Biographic Films in 1959. Any survey of the British humorists of the 1950s and '60s that features the quirky, irreverent *Goon Show* and *Monty Python* should include Godfrey as a shining light.

Godfrey's clever *Do It Yourself Cartoon Kit* (1961) is not only a send-up of animation, but, at a time when the form was reaching for a wider audience, it was a celebration of just how wacky and inventive cartoons could be. It was a forerunner of many indie cartoons. Godfrey won an Oscar for his film *Great*, in 1975.

Bob Godfrey, Dream Doll, 1979

44

CAROLINE LEAF

At a time when there were few women in independent animation, Caroline Leaf was a shining light. She experimented with and developed a number of singular techniques that allowed her to hand-manipulate her materials. Perhaps the most well known of her methods involves manipulating sand on a light box, and the films using this approach have a truly unique look, at once intriguing and expressive. Alongside her technical brilliance, Leaf's characters are full of heart and her stories are passionately told. She is truly a master animator.

Born in Seattle, Leaf joined the National Film Board in 1972. Her first film, *The Owl Who Married a Goose* (1974), was based on an Eskimo tale, and her short *The Street* was nominated for an Oscar in 1976.

Caroline Leaf, The Street, 1976

Caroline Leaf, Two Sisters, 1990

NATIONAL FILM BOARD OF CANADA

Founded in 1939, the Film Board was created to foster and promote excellence and creativity among Canadian filmmakers, encouraging animators to embrace originality and experimentation. As a result a kind of golden age was created that continues to inspire world animation. Film Board artists achieved an almost unparalleled reputation for quality and invention with materials and storytelling, and a number of animation greats flourished there, including Norman McLaren, Richard Condie, Caroline Leaf (see page 45), and many others.

Although the animation department grew over the years, to its credit it never became a production line–style studio. Considering that it was a relatively small operation, the department released a prodigious number of films each year (five to six) and won many awards. In one incredible three-year run, a National Film Board animator won the Oscar each year from 1977 to 1979.

Cordell Baker, The Cat Came Back, 1988

Richard Condie, The Big Snit, 1985

BARRY PURVES

Detail was Disney's great secret, and he made certain that his animators gave it their attention. Chuck Jones, Tex Avery, and Jules Engel sweated the details too, but like Disney's animators, they also had unique situations that encouraged them to make works of art rather than products. Most studio animators do not have that luxury.

Perhaps that is why attention to detail is one of the most common characteristics of independent animation. Indies are not on assembly-line schedules, and so artists can spend time perfecting the small details that add up to a powerful and engaging film. This is certainly the case with the work of Barry Purves.

Purves's exquisite stop-motion films are all detail, and they pack a powerful emotional wallop because of it. These films tackle serious subjects, courageously pushing the medium's thematic boundaries; the storylines are adult and even startlingly dramatic. Purves masterfully manipulates his models to express complex and conflicting emotions, but his technique takes a back seat to his even more compelling storytelling.

English stop-motion animators have a tradition of creating great sets and backdrops, intricate and fabulously detailed like full-blown Hollywood sets in miniature or narrative descriptions from a Dickens novel. Detailed sets can lend an eerie power to stop-motion models, and in Purves's hands this effect gives the films an almost literary quality.

One of the hallmarks of a real work of art is that it is difficult to imagine it being rendered in any other form. This is certainly the case with the animation of Barry Purves. An alumus of England's Aardman Studios, Purves is one of the independent movement's rising stars, and an important filmmaker to watch.

Barry Purves, Achilles, 1996

Barry Purves, Screenplay, 1996

JOANNA QUINN

Like Michael Dudock de Wit (see page 42), Joanna Quinn lives in England, where she teaches, makes television commercials, and illustrates books, all while developing her delightfully animated short films. Her skills as an illustrator show up in her animation style, which has an unmistakably ephemeral character.

Among independent animators Quinn is a real communicator, carefully shaping her subjects and presenting them in a way that is both entertaining and accessible. She has received many awards for her work and was twice nominated for the Academy Award, for her films *Famous Fred* (1997) and *The Canterbury Tales* (1998).

Joanna Quinn,
Girls' Night Out,
1986

Joanna Quinn, Body Beautiful, 1990

OSAMU TEZUKA

It's no stretch to say that Osamu Tezuka is Japan's answer to Walt Disney. The influence that this legendary animator has had on Japanese and American animation cannot be overestimated.

"Dr. Tezuka," as he is known (he is a doctor of medicine), first came to prominence with his character Astro Boy, which was created in the early 1950s after a long study of the great American cartoons of the 1930s. As Dr. Tezuka' studio rose quickly to prominence, he oversaw a wide variety of projects, including features. It is said that his *Kimba the White Lion* (1965) was an inspiration for Disney's *The Lion King* (1994).

Despite the size and success of his animation and merchandising operations, throughout his career Tezuka continued to draw comics, make innovative short films, and experiment with styles. Many animation techniques that are commonplace by using computer graphics today (moving backgrounds, combining live action and animation, detailed robotic characters) were tirelessly innovated by hand at the Tezuka studio.

Tezuka realized that the independent vision was at the heart of the most creative animation. At a time when there was no real market for independent shorts, he was an enthusiastic supporter of the form, creating experimental short films, encouraging young talent, and attending many international festivals. His contribution to the worldwide history of underground animation is enormous.

The influence of American cartoons is obvious in the "big-eyed" look of Tezuka's characters, a hallmark of his style. In turn, his signature big-eyed look continues to be an influence on anime and manga, the great succeeding Japanese animation movements for which he is the spiritual grandfather.

Osamu Tezuka, Animated Self-Portrait, 1988

Osamu Tezuka, Broken Down Film, 1985

WiLL ViNTON

Will Vinton has done more than anyone in the United States to keep the art of stop-motion animation alive and vital. Arriving on the scene in the 1970s, Vinton and his former partner Bob Gardiner collaborated on the stop-motion classic *Closed Mondays*, which won the Oscar in 1974. When Gardiner left the partnership, Vinton went on to create Will Vinton Studios, and to coin the term *claymation*. The studio operation created a string of successful shorts and features as well as groundbreaking commercials, like those for the California Raisins. (Something of a popular phenomenon, Vinton's Raisins even once had their own television special. His current M&M spots are enjoying a similar popularity.)

At the start of the CG (computer graphics) revolution, when stop-motion animation was on the run, Vinton stood his ground with his time-honored medium, producing a number of successful shorts, including a series of pieces based on the life and work of Mark Twain. These eventually became the feature *The Adventures of Mark Twain* (1985). Despite these and other high-profile projects, like the television series *The PJ's*, Vinton remains committed to the short form, and his studio has created many of them.

As the studio has diversified, its artists have begun to use computers to create work that was previously made only by hand. However, their commitment to a high level of artistry remains strong. (The effect computer graphics ultimately have on the art of stop-motion animation is yet to be seen.) Vinton recently produced a *Powerpuff Girls* video, combining models, live-action photography, and miniature sets.

Above and below: Barry Bruce, The Great Cognito, 1982

RiCHARD WiLLiAMS

When *Who Framed Roger Rabbit* was
released in 1988, not even Disney Studios
was up to the old Disney standards. The
highest levels of polish, professionalism,
and attention to detail had become
the province of independent animators
like Richard Williams, who, as anima-
tion director for *Roger Rabbit*, almost
single-handedly reignited mainstream
America's—and Hollywood's—interest
in animation.

Williams was born in Canada but moved
to England in 1955. He was an animation
fanatic since his teenage years and even
visited the Disney Studios as a boy. He
spent three years making his award-
winning independent short *Little Island*,
and he later opened a studio in England
that made commercials and feature-film
titles. However, Williams's passion for
independent animation never wavered.
At a time when the medium was languish-
ing worldwide, his perfectionism kept the
form alive and kicking with handsome,
professional work. He won the Oscar in
1972 for *A Christmas Carol*.

Williams constantly trained and sharp-
ened his own skills and those of his ani-
mators, which gave his studio the
dexterity to experiment in a variety of
styles, from abstraction to classic cartoon.
In whatever style or format, however, the
visuals came first. Williams's feature-film
titles and commercials were so extraordi-
nary that they were screened at animation
festivals worldwide.

Today Williams tours the world, giving lec-
tures and teaching an animation master
class. He remains highly regarded in the
animation community for his superior
artistry and commitment to the art form.

Richard Williams, The Little Island, 1958

Richard Williams, Love Me, Love Me, Love Me, 1962

ZAGReB STUDiO AND PANNONiA STUDiO

Ironically, many great independent animated films were born at studios. The best work of Tex Avery and Chuck Jones demonstrates this, as do the productions from Eastern Europe's Zagreb Studio and Pannonia Studio. What all independent animation has in common is not independence from studios, but independence of vision.

During the 1950s, some of the Soviet Union's poorer countries began to focus on animation as a product for export. Hungary and Yugoslavia gathered together their best talent, provided small budgets, and created "studios" where the artists were essentially left alone to do their work: the ideal recipe for inventive, energetic, independent animation.

Although Yugoslavia's Zagreb and Hungary's Pannonia were state-run studios that employed the assembly-line model of production, each individual animator was nonetheless allowed to follow his or her own inspiration. As a result, these studios produced some of the greatest animation of the twentieth century.

Unencumbered by the prevailing American misconception that animation was just for kids, the Zagreb and Pannonia artists took their cartoons seriously, creating thematically challenging short films that were often quite dark in mood. The films found popular appeal on the American college and art-house circuit. (While distributors in the United States were guilty of replacing the films' soundtracks with "kiddie" soundtracks in an attempt to make them more appealing to American audiences, the beauty of the films was unmistakable.)

Outstanding works—such as Pannonia's Oscar-nominated *Sysiphus* (1974) by Marcell Jankovics, which used stark black brushstrokes to animate a man's effort to push an expanding boulder uphill, and Zagreb's ultra-stylized 1961 comedy *Ersatz (The Substitute),* directed by Dusan Vukotic, which won the Academy Award—alerted American popular audiences to the fact that animation could be more than Looney Tunes.

The Zagreb and Pannonia Studios left behind a great body of work, and their influence on independent animation was significant. American animators Gene Deitch and Chuck Jones, for instance, began attending European animation festivals in the early 1960s, and Deitch settled in Prague for the rest of his career. The impact of the Eastern Europeans can be seen in Jones's film, *The Dot and the Line,* which won an Academy Award in 1965.

Dusan Vukotic, Ersatz, 1961

Marcell Jankovics, Son of the White Mare, 1980

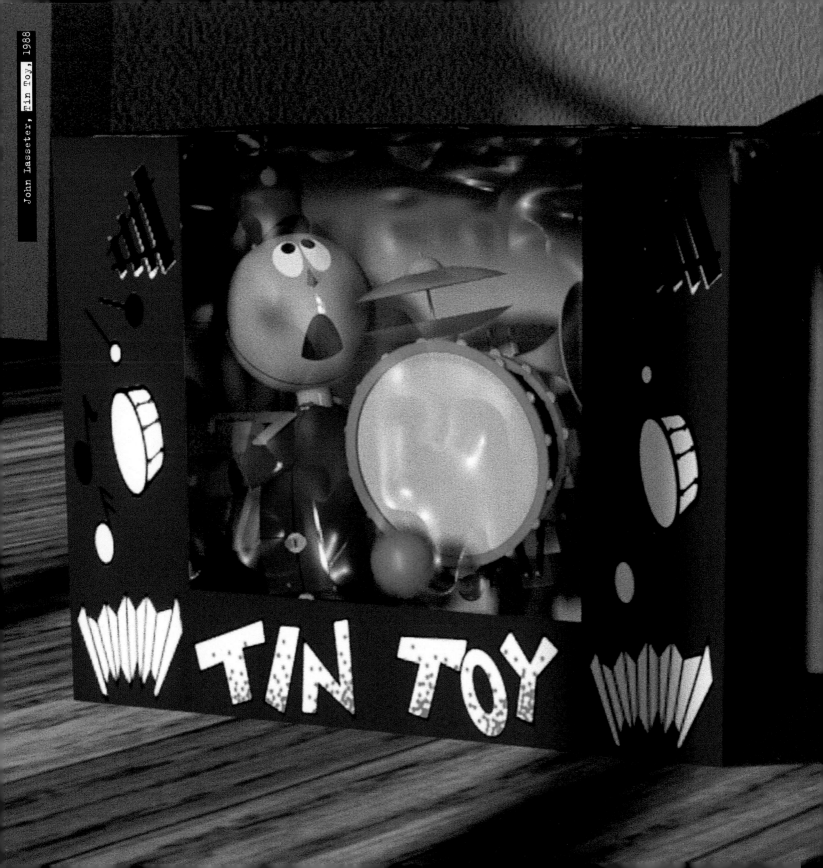

TIN TOY

The Top Ten Spike & Mike Festival Cartoons of All Time

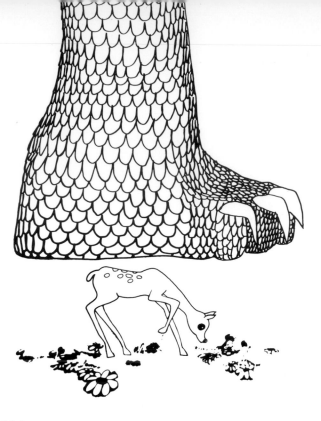

BAMBi MeeTS GODZiLLA

1969. Written and directed by Marv Newland. Music: Gioacchino Rossini, from the *William Tell Overture*

The father of all "Sick & Twisted" animation, *Bambi Meets Godzilla* is an acknowledged classic. Produced on a literal shoestring, in black and white, running exactly one minute and thirty seconds, with a soundtrack consisting of one lone piece of public-domain music—and fewer than twenty actual drawings—it is minimalist filmmaking at its finest.

The film relies on the audience's previous knowledge of Walt Disney's Bambi and Japan's famous monster Godzilla. It opens with cute line-art animation of Bambi, the little deer, grazing in the grass. The title appears and the audience anticipates a story, a fable, perhaps an adventure. As

Bambi grazes, the credits continue: "Written by Marv Newland, Screenplay by Marv Newland, Choreography by Marv Newland, Bambi's wardrobe by Marv Newland, Produced by Marv Newland"

This credit roll sets up a possibility that this film may be of great depth and length. "Marv Newland produced by Mr. & Mrs. Newland" is the final credit when suddenly, STOMP, Godzilla's giant scaly foot crushes poor little Bambi.

"The End" title appears. And, of course, it is exactly what would happen if Bambi met Godzilla. We never saw the punch line coming. The joke was on us.

Marv Newland created this film in a mere two weeks while attending the Art Center College of Design in Los Angeles. It was

substituted for his term project when the live-action film he was shooting for six weeks could not be completed. It turned out to be the first animated film ever produced at Art Center College and set Newland off on a distinguished career as an animator and producer.

Coincidently, Newland made *Bambi Meets Godzilla* in the house he was renting from Adriana Caselotti, the voice of Disney's Snow White. On a certain level, his stomping of Bambi was symbolic of the changes occurring in animation at the time. In one small step, it spit squarely in the animation establishment's eye, at the same time inspiring a new generation of independent artists to think in a new, twisted way.

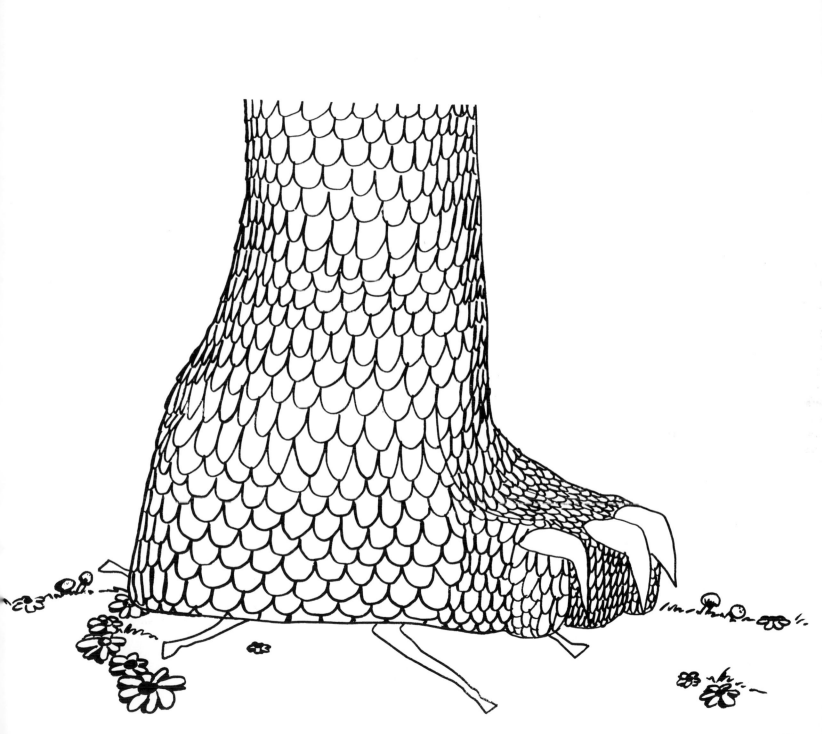

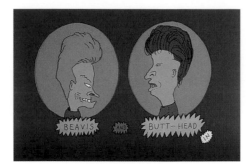

BEAVIS AND BUTT-HEAD IN PEACE, LOVE AND UNDERSTANDING

1992. Animation and voices by Mike Judge. Characters created by Mike Judge. Creative consultant: Robin Syler. Cel painting: Cesca Judge, Diana Johnson, Judy Tucker, Leann Wooten. Sound recording: John Davis. Sound mix: Byron Wilson. Film editing: Doug Bryan. Thanks to Bob Patterson and DNA Productions

Mike Judge's Beavis and Butt-head have grown up and gone on to great fame on MTV, but they were born and raised in Spike & Mike's Sick & Twisted Animation

Festival. *Frog Baseball* (1992) was their debut film—a nasty little piece that has the boys abusing an amphibian with a bat—but it was their second appearance in *Peace, Love and Understanding* that established their twisted personalities and gave Judge a chance to do a more wicked satire.

The film starts out with Beavis and Butt-head sniffing glue and watching TV, an infomercial spoof featuring an Asian American who has made it big and offers the same to home viewers. To Butt-head it is an excuse to stretch his eyes and mock the man's accent, "Ahh, Me Chinese!" This is followed by an ad for a Monster Truck Rally, and the guys decide to go.

Cut to the crowd of spectators. Beavis and Butt-head sit in the front row, discussing stuff like "What if you stuck a piece of dynamite in somebody's butt—and then lit it? That would be cool!"

A monster truck smashes a Hyundai automobile and the crowd cheers. Butt-head hits on a girl with a clever pick-up line, "Hey baby, want to sniff some glue?" Then hippie-dippy singer David Van Driessen (an early version of Beavis and Butt-head's teacher in the TV series) sings a tribute to Earth Day, but he gets smashed by the monster truck. The truck is out of control and smashes a row of port-a-potties. The smashed toilets emit a brown cloud over the truck stadium. Butt-head recognizes it as "Sterculeus, the God of Feces." This is a vengeful god who takes revenge for "desecrating my sanctuaries" by filling the stadium with feces. The end title reads: "To be discontinued."

Crude and lewd, the Beavis and Butt-head films were picked up to air on MTV's animated anthology *Liquid Television*. Within a year MTV began the series, and the rest is history.

Mike Judge wanted to break into comedy and Hollywood filmmaking but had no idea how to do it. He tried his hand at animation and recalled how little money he spent to make his first film.

"I put my first film on VHS tape at a 'transfer your home movies to video' place. Dubbed the sound from a cassette recorder. Made twenty copies of it, called information, got *Animation Magazine*, sent it out to anybody I could. After Spike said he liked it I spent between five and six hundred dollars to make a finished film print. I went to a mixing theater in Dallas with my little four-track cassette recorder and plugged it into a huge 16mm mag theater mixer. Did it all there and made prints. Spike paid me two thousand dollars to license it, so already I'm into profit for my first film. Nobody was more surprised than me on how fast all this happened."

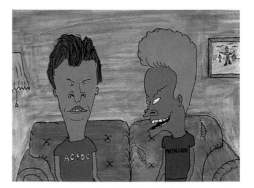

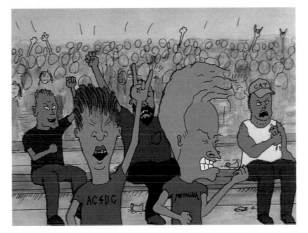

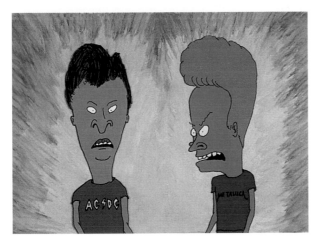

THE SPIRIT OF CHRISTMAS

1995. Written and directed by Trey Parker and Matt Stone

This little cut-out film, made by two University of Colorado film students, Trey Parker and Matt Stone, became the biggest "underground" cartoon of the 1990s.

While their classmates took the film noir and art house route, Parker and Stone made crudely produced comedic shorts, including a Student Academy Award winner *American History* and the original *Frosty vs. Santa Claus*, a precursor to *The Spirit of Christmas*. *Frosty vs. Santa Claus* caught the eye of Brian Graden, a Fox executive and now the president of MTV, who commissioned the team to create a video Christmas card that he could send to his friends, for a two-thousand-dollar budget.

"I did the animation using construction paper cutouts," Parker says, "and we both improvised the dialogue, screaming obscenities at each other in my basement while my mom was baking fudge upstairs. It cost seven hundred fifty dollars and we pocketed the rest."

The film only carries bogus credits ("Robert T. Pooner presents a Kranklin/Blass production")—no one thought anyone outside Graden's circle of friends would ever screen it.

It begins with a quartet of boys, nestled in the small town of South Park, singing "We Wish You A Merry Christmas." Little Stan stops the song by asking, "Wait a minute. Aren't you Jewish, Kyle? Jewish people don't celebrate Christmas!"

Kyle starts to sing "The Dreidel Song," but Cartman refuses to join in, ("Hanukkah sucks!"). After much cursing among them, Jesus appears. "Holy shit, it's Jesus! He's come to kill you because you're Jewish!"

Jesus, who is actually looking for Santa Claus, asks the boys for directions to the

mall. They lead him to the department-store Santa ("So, we meet again!" declares the jolly fat man upon first sight). A fight ensues, using a variety of mystical Chinese martial-arts techniques. Collateral damage: they kill Kenny.

Evenly matched, both Santa and Jesus ask the boys for help. They turn to fey Olympic skating champ Brian Boitano, who calms things down by explaining the true meaning of Christmas.

Jesus and Santa make up ("I'll buy you an orange smoothie" says Santa), leaving the boys to ponder this miraculous day: "We actually met *the* Brian Boitano!" They conclude that Christmas is really about presents, and "if you are Jewish you get presents for eight days!" The South Park boys march off screen singing, "The Dreidel Song."

The crude cutouts evoke memories of the cheap TV holiday cartoons of the 1960s —*A Charlie Brown Christmas, Davy & Goliath, Rudolph the Red-Nosed Reindeer*— and yet are unlike anything seen to date. Parker and Stone went on to adapt this short into TV's smash *South Park*, which in turn became a successful feature-length film in 2000.

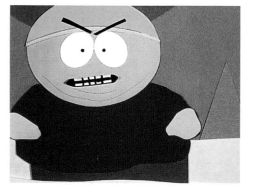

YOUR FACE

1987. A Film by Bill Plympton. Music: Maureen McElheron. Camera: Andrew Wilson, Gary Becker. Sound: Full House. Editor: Stephen Barr

"Your face is like a song, your sweet eyes whisper and I want to sing along." So begins Bill Plympton's animated tour-de-force, *Your Face*. Those lyrics are heard via a warped, slowed-down vocal recording and piano solo that haunt the background, while Plympton's sketchy images stretch, contort, evolve, and devolve before our eyes.

A mustachioed caricature of a man begins to sing this song, but within seconds the lip sync gets thrown out the window. His mouth begins to move around his face, his facial features then twirl 360° around his head, and then his head twists like a dishrag being rung.

Sometimes it is hard to verbalize such intense animated energy. Words cannot describe the joy of watching this film, something wonderful that only hand-drawn animation can accomplish. This is pure, unrestrained cartoon bliss.

Plympton is a great animator and this film proves it. His subsequent shorts are loaded with great gags, but the simplicity, and insanity, of *Your Face* is comic genius.

The man's head crawls off his neck and runs down his shoulder, his face expands and explodes, it slices apart, it implodes and becomes cubist, and it wraps around itself. Another version of the man enters his right ear and exits his left. His large

smile cuts the top part of his head off, his nostrils engulf his face, and multiple heads grow multiple heads.

The camera pulls back at last, revealing the man simply sitting on a chair. As the ground opens, human features rise from the ground and literally swallow him up, ending the song, ending the film.

Plympton's surreal opus cost three thousand dollars to produce, earned an Academy Award nomination, and launched his successful career as an independent animator. He has gone on to create more than forty shorts and four animated features.

LUPO THE BUTCHER

1987. Design, animation, and direction by Danny Antonucci. Produced by Marv Newland. An International Rocketship Production. Inking: Bill Schwarz. Airbrush: J. Falconer. Checking: Dieter Mueller, Gary Lambeth, Mary Sia Nowaczynski. Paint: Gary Lambeth, Monica K. Rain, Kelly Carlisle, Lynn Wilkin, Andi Smith. Sound mix: Barry P. Jones. Negative: Gay Blake. Camera: Tom Brydon

The viewer is led into Lupo's meat shop and stops in the backroom, where the butcher begins to cut into some ribmeat with his cleaver. He's muttering to himself in a thick Italian accent: "Son of a bitch, piece of shit job. I quit—fuckin' I don' know."

He cuts the ribcage, dropping a piece of meat on the floor, which he kicks away, still cursing his fate. Lupo the butcher makes another cut—but this time accidentally chopping his finger off.

"Fucking sheeet!" Blood spurts everywhere as he screams and curses. Next his arms come off, then his legs—his whole

body falls in pieces to the floor—his head still cursing loudly. Poetic justice, perhaps?

Lupo's decapitated head pops through the closing iris out, writhing and cursing its way through the credits. Danny Antonucci's *Lupo the Butcher* is sick, twisted, slick, shocking, and hilarious.

"Lupo came out of my upbringing," says Antonucci. "The character came from those who surrounded me—my dad and my uncle—Italian immigrants, and their mentality."

Produced by Marv Newland's International Rocketship Ltd. in Vancouver, B.C., *Lupo* was animated by Antonucci in his down time between commercial projects at New-land's animation studio. Newland *(Bambi Meets Godzilla)* encouraged his young animators to make independent films, which his studio would finish in color.

"Lupo, at first, really went big in Europe," recalls Antonucci. "Then Spike & Mike showed it all over to the folks in the States. Guns & Roses showed it on their tour. People were calling me about doing a Lupo feature. I can't ever imagine doing that."

REJECTED

2000. A Film by Don Hertzfeldt. Edited by Rebecca Moline. Voices: Robert May, with Jennifer Nyholm and Don Hertzfeldt. Sound production: Tim Kehl. A Bitter Films release

With their stick figures, bad attitude, and outrageously funny ideas, Don Hertzfeldt's films have become the latest favorites to emerge from the Spike & Mike Festival. *Rejected* is Hertzfeldt's nine-minute masterpiece of animation angst—and it was duly recognized by being nominated for an Academy Award.

The film sets up a strong premise for its outrageous gags, then proceeds to tear everything in its path apart. Starting out as documentation of Hertzfeldt's (fictional) failed animation career, the film soon drags the viewer into the mind of the mad cartoonist—with echoes of Tex Avery (*King Size Canary*), Chuck Jones (*Duck Amuck*) and Max Fleischer (*Koko's Earth Control*)—leaving the viewer laughing all the way to oblivion.

"In the spring of 1999, the Family Learning Channel commissioned animator Don Hertzfeldt to produce promotional segments for their network," states an opening title card. "The cartoons were completed in five weeks. The Family Learning Channel rejected all of them upon review and they never aired." What follows are the rejected pieces, created by a cartoonist who has clearly lost his mind.

The first piece looks like a demented cereal commercial. A stick figure with a bowl and an oversized utensil cries, "My spoon is too big!"

Blood-spurting, out-of-sync figures speak in non-sequitur dialogue, saying things like "Tuesday's coming, did you bring your coat?" and "I live in a giant bucket." Silly people in hats begin beating up a derby-topped man. It is all followed by a calming "You're watching the Family Learning Channel" end tag.

"Meanwhile the Johnson & Mills Corporation approached Don to produce a series of advertisements for their assorted home products. Upon submittal of the finished commercials, they too were rejected outright."

This is demonstrated by a series of gruesome segments packaged as friendly commercial pitches: The first shows an alien pulling out a man's eyes, then cuts to a package of Johnson & Mill's Fish Sticks, "Now with more sodium!"

The second illustrates a man pulling the stomach off another and putting it on his head, causing blood everywhere, then cuts to a package of Johnson & Mill's Bean Lard Mulch, "Now with Vitamin C."

The commercial for Johnson & Mill's Kelp Dip has a baby taking his first steps, only to fall down a flight of stairs. The final spot shows Cotton Swabs happily dancing until one starts gushing red fluid ("My anus is bleeding!").

"Don's clear and steady downhill state continued. Soon he was completing commercials entirely with his left hand." This is illustrated with even sketchier, crudely drawn stick figures spouting gibberish.

"Perhaps it was the animator's creative stagnation in the commercial world or deeper loss of individuality therein. Without meaningful input and lacking any remaining reason or coherent narrative structure, the rejected cartoons grew unstable . . . then began to fall apart."

Hertzfeldt's animation world is destroyed as a series of rips, creases, folds, and crumpled landscapes overtake his creations. His characters run for their lives as the camera shakes, the paper universe shreds, and the characters are swallowed up in a black hole.

The film ultimately conveys the spirit of the optimistic, yet frustrated, artist against the corporate mentality that routinely numbs creative work—or it could be that Hertzfeldt has truly gone mad. Either way, *Rejected* has been roundly accepted at the Spike & Mike shows by getting big laughs.

1989. Directed and animated by Nick Park. An Aardman Animations Limited Production for Channel 4. Producer: Sara Mullock. Assistant producer: Alan Gardner. Interviewer: Julie Sedgwick. Editor: William Ennals. Dubbing mixer: Aard Wirtz. Models and sets: Michael Wright, Greg Boulton, John Parsons, Cliff Thorn. Animal sculpting: Debbie Smith. Photography: David Sproxton, David Alex Riddett, Andy MacCormack, Fred Reed

Released just slightly ahead of Nick Park/Aardman Animation's initial Wallace & Gromit adventure, *A Grand Day Out* (1989), *Creature Comforts* was commissioned by Britain's Channel 4. It was inspired by *Conversation Pieces*, a previous series of Aardman films using real-life soundtracks with everyday people, not actors, discussing their points of view. The five-minute *Creature Comforts* became a genuine international crowd pleaser, winning numerous awards, including the 1990 Oscar, and putting Nick Park and Aardman Animation on the map.

Stop-motion, clay-animated zoo animals are interviewed in their environments; the prerecorded soundtrack, consisting mainly of old British women and children being interviewed about their home lives and what they like to eat, is made hilariously poignant by the animated actors.

A polar bear clan sets the scene, telling the camera, "Zoos are very important to animals." Armadillos ("We're well looked after"), turtles ("Comfortable, I suppose"), and a gorilla ("I'd like to go somewhere a bit hotter") give succinct answers. A jaguar

with a South American accent steals the show ("We like MEAT," "In Brazil you have SPACE") with his attitude.

This film marked our introduction to Nick Park's unique character animation. His designs feature round-eyed characters with flawless mouth movements and sincere facial expressions—elements that later endeared us to Wallace & Gromit. We laugh at the animals' characters, their body language, and the British types they send up. Standouts include a bush baby with thick eye glasses and a group of unusual spotted birds.

As with most great films, the idea is beautifully simple: real voices coming out of hilarious looking zoo animals. "People now say how well-suited the voices are to the animals, but in fact I changed things around a lot," says Park. "My theory is that you can make anything fit anything. What is most important is how you do it."

Nick Park discovered how to do it—and with this film we discovered Nick Park. *Creature Comforts* was a delightful debut.

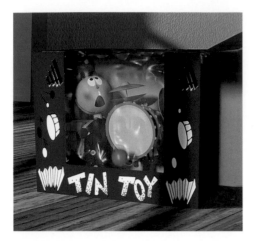

TiN TOY

1988. Direction, animation, and story by John Lasseter. A Pixar Production. Technical directors: William Reeves, Eben Ostby. Additional animation: William Reeves, Eben Ostby, Craig Good. Modeling: William Reeves, Eben Ostby, John Lasseter, Craig Good. Sound: Gary Rydstrom, Sprocket Systems. Production coordination: Ralph Guggenheim, Susan Anderson, Deirdre Waim. Best boy: Tony Apodaca

The computer-animation powerhouse Pixar would not be where it is today without the pioneering short films that director John Lasseter made in the 1980s. Nominated for an Academy Award for *Luxo Jr.* in 1985, Lasseter hit paydirt in 1988 with the Oscar winning *Tin Toy*—one of the most popular animated shorts ever and the precursor to the landmark animated feature *Toy Story*.

The short is told from the point of view of Tinny, a wind-up, one-man-band tin toy, whom we meet on a mostly barren living-room floor. When baby Billy enters the room he seems more like a giant monster than an infant.

At first Tinny smiles at the titanic tot, but when Billy bites into a plastic teething ring, this alarms the tiny tin toy. When the baby bashes a toy necklace, the tin musician makes a run for it. He does not want to be bashed next.

After a small chase, the little music maker finds safety under the sofa, where he encounters the other petrified playthings

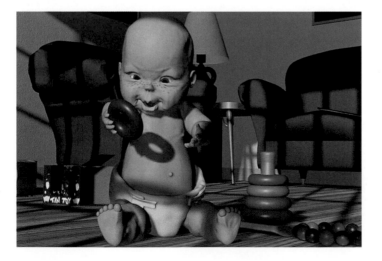

(dolls, toy animals, and robots) hiding out for their lives. Billy falls down and starts to cry. Tinny feels sorry—and realizes what he must do. Summoning his courage, the tin toy marches out to entertain the baby.

Billy picks him up and throws him aside. Tinny survives without a scratch, and now the baby has stopped crying. He's found a new toy to torment. Only it is not a toy. It is the original "Tin Toy" box, the one Tinny came in. The tin toy ends up chasing the baby around the room—he wants to be used as originally intended.

The ability to provide inanimate objects with real personalities was a specialty of Walt Disney's films in the 1930s. Lasseter brought this up to date, first with Luxo lamps, then with toys. *Tin Toy* was constructed like a traditional hand-drawn animated short but rendered in what was then state-of-the-art computer graphics. Audiences strongly identified (and still do) with the little tin toy who feels joy and terror at his new responsibility, the mammoth baby Billy.

The idea of toys with lives of their own—and their realization of their purpose in life—would echo in the later *Toy Story* movies. *Tin Toy* also broke ground with its computer animation of a human being, the infant Billy. Fifteen years later, the baby scenes are still quite impressive, particularly the realistic drool and sneezes.

This charming short still has it all: humor, heart and spectacular visuals. There was never any doubt that Lasseter would go on to bigger and better things. And audiences who screened *Tin Toy* at the Spike & Mike Festival of Animation in 1988 knew it all along.

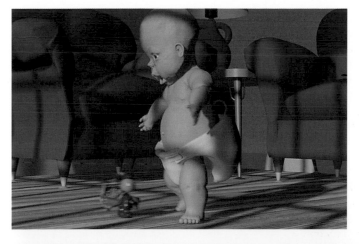

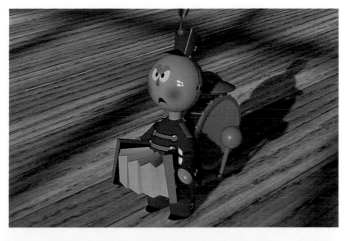

NO NECK JOE

1991. Written, animated, and directed by Craig McCracken. Music: Eric Stefan. Thanks to: Conrad Vernon, Eric Stefan, Lou Romano, Miles Thompson, Nate Pacheo, Dan Taylor, Mark Osbourne, Pete Houser, Tim Meyers. Produced by Spike & Mike

Craig McCracken's freshman student film *No Neck Joe* was picked up by Spike and Mike, who immediately recognized that the warped adventures of this neck-challenged lad would become an audience favorite.

McCracken had done three of these little sixty-second (or less) films on video as a CalArts student project. Spike and Mike reshot them on film and commissioned McCracken to make two more to create a five-minute piece.

Probably the sweetest of all the "Sick & Twisted" creations, these films allow the audience to laugh at a person's handicap (albeit an imaginary one) without feeling too guilty about it. Joe is incredibly cute, with his large round eyes, a propeller beanie cap on his head, his pink bare chest directly attached to his large face, and arms protruding where his ears should be.

Some of the skits work to Joe's no-neck advantage—warding off Dracula who has no place to bite, or confounding a Western sheriff and hangman who have no place to put the noose—but most play up his neck-less annoyances and challenges, particularly against two bullies who taunt him at every turn.

Other situations in the first cartoon include the bullies handing Joe a wrapped gift— is it a toy truck, robot or football? No, It's a turtleneck sweater!—and a visit to the zoo, where the giraffes have a good laugh when they spot Joe walking by.

The shorts were so popular, Spike and Mike commissioned a second series. But McCracken's school work prevented him from producing the sequel. He wrote and storyboarded four more bits, which were animated by Tim Hatcher at DNA Productions in Austin, Texas.

The follow-up set presents these storylines: 1) No Neck Joe walks down the street and shocks the bullies with his long neck, but it's just a dream; 2) The bullies are looking at something up in the sky, but when No Neck Joe tries to direct his gaze in that direction he falls over; 3) No Neck Joe has a quarter. Bully #1 comes by with a placard "Candy for sale 25¢." Joe buys a piece and eats it. Bully #2 comes by with a sign stating "Necks for sale 25¢," but Joe spent his only quarter on candy. The bullies laugh at him; 4) No Neck Joe goes to Africa where to take photos of all the wild animals but is saddened by the sight of Zulu natives with long necks.

McCracken's sophomore student film, *Whoopass Stew*, made its debut in the "Sick & Twisted" Festival of 1993. Remade at Hanna-Barbera a few years later, the film was transformed into *The Powerpuff Girls*, becoming one of the biggest hits on the Cartoon Network and a merchandising phenomenon.

THE DIRDY BIRDY

1994. Written, produced, and directed by John R. Dilworth. A Stretch Films Production. Additional animation: Jim Petropolous and Marty Polansky. Assistant animation: Jim Petropolous, Ed Mironiak, Michelle Meeker, Marty Polansky. Color styling and backgrounds: Margaret Frey. Ink and paint: Chelsea Animation Co. Production manager: Janet Scagnelli. Ink and paint artists: Pat Roberts and Donna Brooks. Photography: Ron Bleicher. Sound design and mix: Tim Borquez and Michael Geisler. Special thanks to Mark Heller and Melanie Grisanti. Starring Purdy the Dirdy Birdy and Fergurina the Cat

A disgruntled lady cat, sitting on the branch of a tree, is approached by a zany bird who appears to be smitten by the love bug. The cat tries to ignore the bird but the bird appears and reappears, each time mooning the cat and disrupting her solitude. The cat punches the bird off the branch with a human fist, ignites it with a blowtorch, inflates its birdy butt with helium, and dunks the fowl in nuclear waste.

Returning each time with a flower within its buttocks, the little feathered freak is finally fooled by a cardboard cutout of the cat. Broken hearted, the birdy cries herself to death. Having a change of heart, the cat boots the Grim Reaper off the tree branch and revives the bird. The bird gives his heart (the organ) to the cat, who rejects it. Both begin to make horrifying faces at each other and eventually laugh. Just when you think they might become friends, the bird resumes his mooning—and the cat continues to push the bird away.

New York independent animator John Dilworth had been producing commercials, TV pilots, and a variety of short films in the early 1990s. "Around the time Ren & Stimpy started, there was a discussion among local animation artists and executives that you couldn't communicate a sophisticated concept using vulgar humor," recalls Dilworth. "And that really bothered me, so I made The Dirdy Birdy.

"The Dirdy Birdy portrays a complicated relationship, a thoroughly dysfunctional relationship, and I express that dysfunction with buttocks jokes—not much different than they were doing on Ren & Stimpy, only the effect is totally different.

"I was always interested in relationships. All of my films are about relationships. Some of them are autobiographical. The Dirdy Birdy was a little more complicated because the challenges were to tell a story that had levels, without dialogue, and to express larger ideas I had: why are people attracted to others who are inappropriate, the wrong people? And what it is that makes people attracted to each other?

"What was it about Fergurina's personality that the Dirdy Birdy just wanted to express his love for her? The specific way he did it. Those are the things that interest me about human nature."

Dilworth later wrote and directed the Oscar-nominated short film The Chicken from Outer Space, which was the pilot for the Cartoon Network's Courage the Cowardly Dog.

Even More Independent Films

Hundreds of films and images from a host of talented animators have left their mark on the Spike & Mike festivals throughout the years. The following gallery represents a few of those amazing memories. The works fly by at a rate of twenty-four frames per second, but their artistry is evident in every still image. Their techniques, skills, and messages are wildly diverse, but the artists all share a desire to push the envelope of what animation can be.

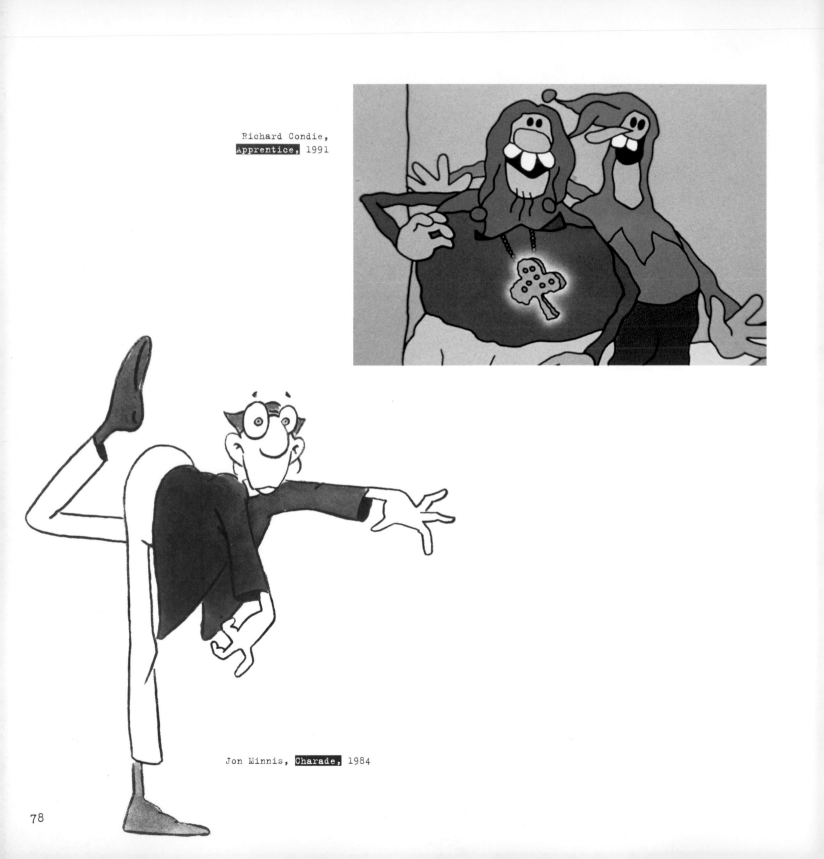

Richard Condie,
Apprentice, 1991

Jon Minnis, Charade, 1984

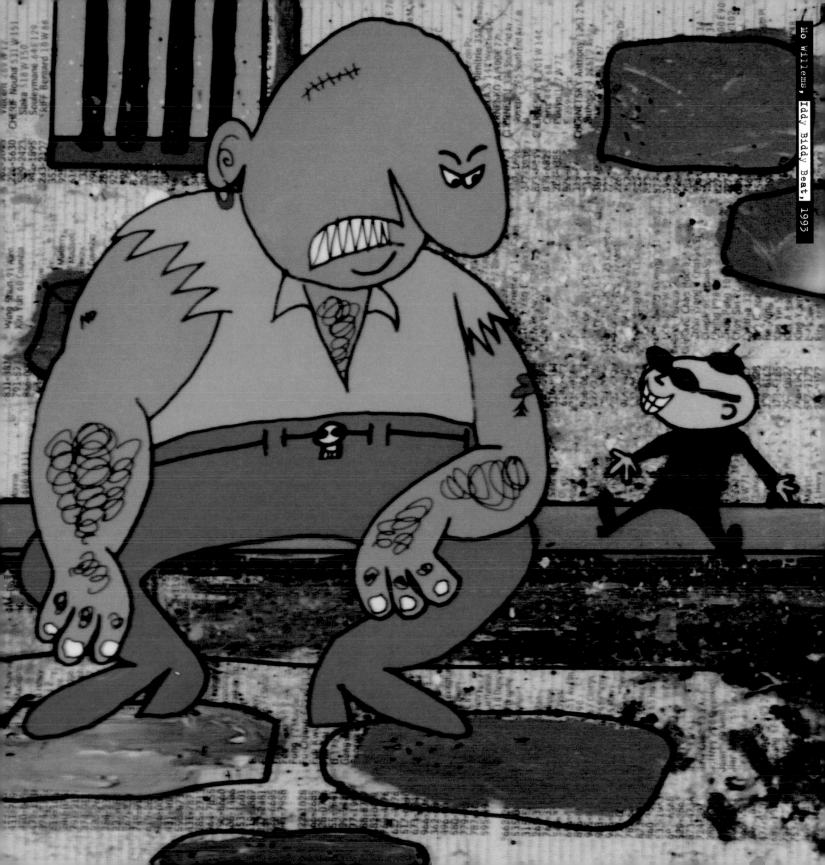
Mo Willems, Iddy Biddy Beat, 1993

Cathy Joritz, Give AIDS the Freeze!, 1991

Raymond S. Persi and
Matthew Nastuk, Ghost of
Stephen Foster, 1999

Walter Santucci, The Cat,
the Cow, and the Beautiful
Fish, 1992

Miles Thompson, Empty Roll, 1991

Gregory Ecklund, Lloyd's Lunch Box, 1994

Jan Pinkava (Pixar), Geri's Game, 1997

Kevin Kalliher, Home Honey, I'm High, 1994

Miles Thompson, Hut Sluts, 1993

Mike McKenna and Bob Sabiston, **Grinning Evil Death,** 1990

Joanna Priestley, **She-Bop,** 1988

Alison Snowden,
Second Class Mail,
1984

Craig Bartlett, The Arnold Waltz, 1990

Brad Caslor, Get a Job, 1985

Nicole van Goethem,
A Greek Tragedy, 1986

Peter Docter, Next Door, 1992

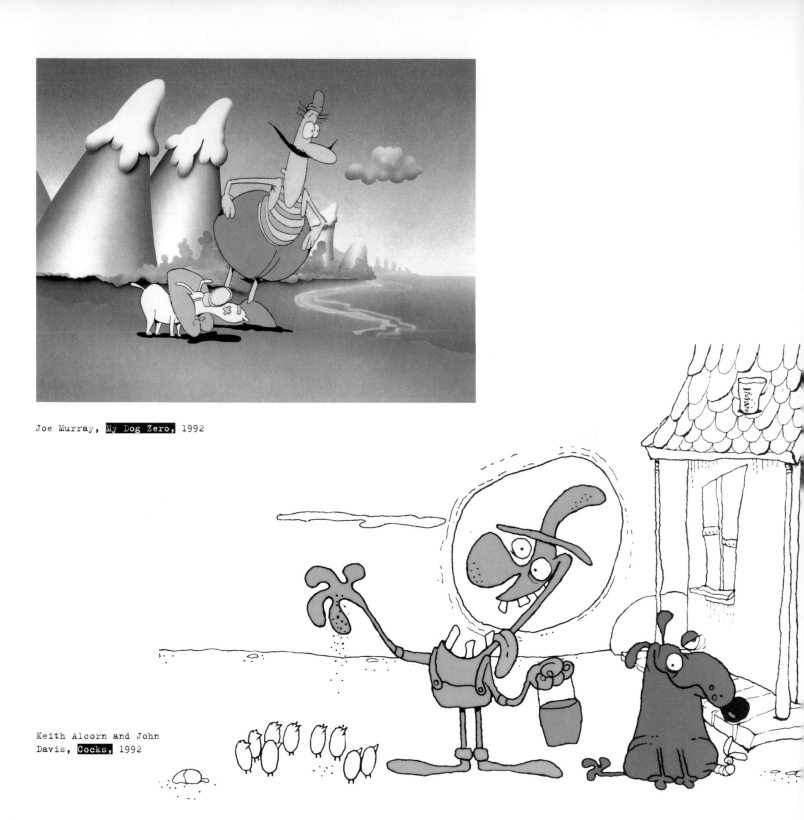

Joe Murray, My Dog Zero, 1992

Keith Alcorn and John Davis, Cocks, 1992

Daniel Greaves, Manipulation, 1992

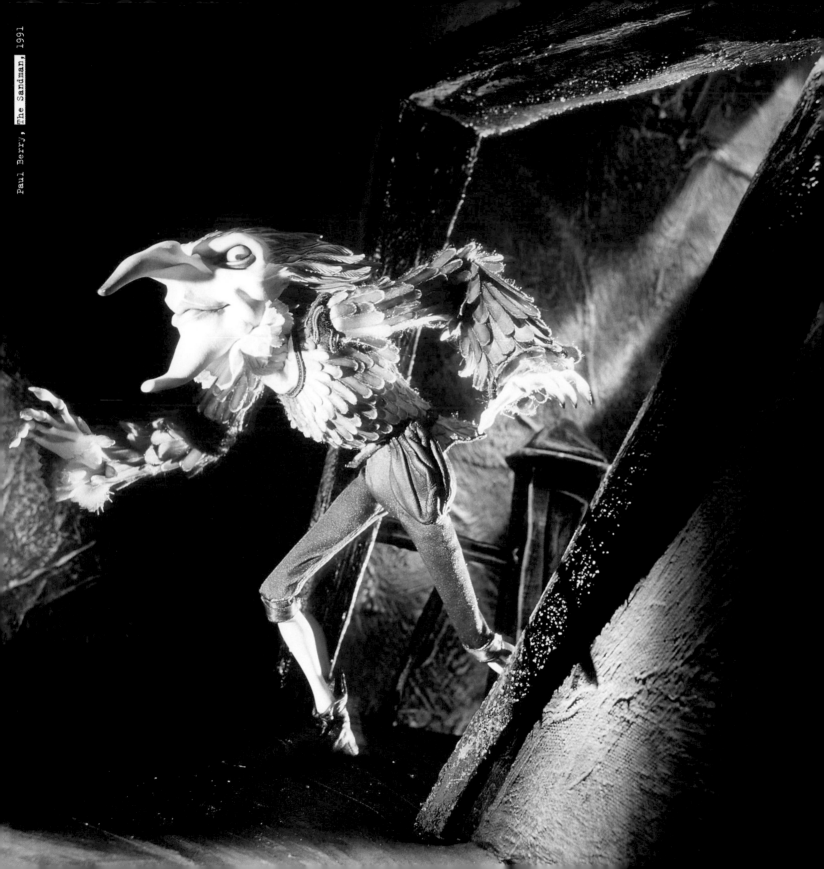

Chris Wedge
(Blue Sky),
Bunny, 1998

Christoph and Wolfgang Lauenstein, Balance, 1989

DNA Productions, One Ration Under God, 1994

Brett Koth, <mark>Happy Hour,</mark> 1986

Joan Gratz, Legacy, 1979

John Schnall, I Was a Thanksgiving Turkey, 1986

Kirk Henderson, Cat and Mouse, 1985

Karen Aqua,
Kakania, 1989

Dave Smith, 1996

Deborah Solomon, Mrs. Matisse, 1994

Outlaw
Animators Speak

Bill Plympton, Plymptoons, 1990

Bill Plympton Interview

Bill Plympton's animated films have appeared on PBS, MTV, and the Cartoon Network. He has won numerous awards, including an Academy Award Nomination for *Your Face* (1987).

JB *How did you first encounter Spike and Mike?*

BP I first encountered Mike Gribble at Annecy. Certainly he was a caricature, a figure, a cartoon character I really was attracted to. Got along very well with him.

He really loved animation and was a bon vivant. He took us all out to dinner, bought us drinks. It intrigued me.

JB *When you made your first film (Your Face) did you know there was any show-case for it, like the Spike & Mike Festival?*

BP No, I didn't know that.

JB *Tell me about the appearances you made at the Festival of Animation.*

BP It was a fun show to go to. Some of my best memories are of going down to La

Jolla. The shows were a revelation. First of all, you see lines around the block. This is the La Jolla Art Museum. Young college kids, boisterous, partying on the sidewalk. Then you go inside and its like a circus. You have beach balls, performing dogs, people in funny costumes, Spike selling t-shirts, posters, and videos. It was really a revelation for me that this world existed. It was much different than Terry Thoren's show, which was much more professional and corporate. Spike and Mike would bring me on stage and ask me funny ques-tions, and they would have me announce someone's birthday, which would freak out the person in the audience. I'd sign t-shirts, bras, breasts. Did this in Santa Barbara, San Francisco, Washington D.C., Minneapolis. Always a lot of fun. The dog chasing balloons. I'd hang out with John Lasseter—he's a wild man. He and Andrew Stanton, we would all go out, and they'd throw pies at each other. They were like little kids. That's the Mike Gribble effect on everybody. It was a party. Always a party.

JB *Did you get into any trouble at the festivals?*

BP Once in La Jolla I told Weird Al Yankovic's girlfriend that I had never been to Tijuana. And I suggested we go. Right now.

I had my suitcase in my rental car, and we drove down, about twenty minutes away. I didn't want to park my car in a lot, so I took it across the border, which is a no-no for a rental car because if it gets stolen or any-thing, you have to pay the entire price, and things get stolen down there. So I thought I'd be smart. I won't park—we'll just drive

around to see the main street and drive right back.

So we drove down the main street and doubled back on a back street, and we got halfway down the street and saw a sign that said "Wrong Way." And then these lights flashed and these kids with guns came out of this cop car. In broken English they said we were going the wrong way down a one-way street and they were going to take us into jail for the night.

I freaked out, and they said, "Tell you what, you pay us all the money you have and we'll let you go." Fortunately I only had thirty dollars in my wallet. However, in my suitcase I had over two hundred dollars from selling t-shirts and videos at the Spike & Mike show. I offered them twenty dollars and they said, "No, no, we're going to take you to jail—are you sure your don't have any more money?" And they went through my suitcase, took all my clothes out, but didn't find my money. They said. "You follow us to prison," and they drove ahead.

We started to follow, but then they took off. We looked at each other. Man, were we lucky. We went back to Spike and Mike and they scolded us for taking a rental car into Tijuana.

JB *Any particular memories of Mike?*

BP Mike was a great guy. He would always pick up the tab for anything. I remember one time he came to New York, went to the Strand Book Store, and bought a bunch of books. He had one book on weird inquisition, execution, and torture machines. I told him I could make a neat

film out of that and he said, "Here, take it." He just gave it to me. That kind of generosity really impressed me. That's why I didn't mind making less money with Spike and Mike. They were great, and it was just such a fun event, you just wanted to be part of it.

JB *Does exposure in these festivals help your animation career?*

BP Absolutely yes. It's certainly not like being on MTV, but, especially on the West Coast, the festival created a large part of my fan base.

JB *I understand you had an incident with one of the Los Angeles critics.*

BP In 1990 (or so) Charles Solomon in the *Los Angeles Times* gave Spike & Mike's festival a scathing review, saying the animation was amateurish. Mike called me up and said, "We've had enough of Charles Solomon. We're gonna get him fired from the *L.A. Times*. We are asking animators from all over the world to send in letters protesting his lack of knowledge of animation."

I said, "I don't know. I'm not even in the show. I don't think I should get involved." They said Marv Newland was doing it, Danny Antonucci, "they're all doing it. We've got people sending letters in."

Well, maybe if those guys think its ok, I'll send a letter. So I wrote this letter, I really felt it. I didn't like Solomon's taste in films anyway. It wasn't just for Spike & Mike that I was doing it.

I talked to Marv Newland a month later. I

said, "Hey Marv. Did you send a letter to the *L.A. Times*?" He said, "Nay, it's a bunch of bullshit. Nobody sent letters." So I'm sure they sent on this lone letter to Charles Solomon saying, "Fire him, he's no good, he has no taste for animation."

The year after that, *The Tune* [Plympton's 1992 feature film] came out. Solomon reviewed it for the *L.A. Times*. It was one of the saddest, most negative reviews I've ever read. Literally, he wrote, "If you take two pieces of paper and flop them back and forth you'll come up with a better film than *The Tune*."

And, as a result, I lost between ten and twenty thousand dollars.

JB *How did you get into animation? You were originally a print cartoonist, right?*

BP I tried to do animation in college. I did a radiograph on acetate film, where I would do the drawing, shoot it, and rub off the arm or leg, whatever was moving, and redraw it under the camera. It was shot upside down. It's called *The Turn On*. It was frustrating. When I moved to New York I tried another film where I shot pieces of paper on the floor, à la *South Park*, with an 8mm Bolex camera. That was an experiment in timing. I never did anything with that because it was 8mm, totally undistributable. And I still didn't really know there was a scene out there. In the 1970s there wasn't an animation scene. I knew Bob Gardiner and Will Vinton [Portland-based animators who won the 1975 Oscar for their claymation short *Closed Mondays*], and I knew they were really successful with their animation. I used to hang out with them, Gardiner especially.

I remember seeing in college Bob God-frey's *Do It Yourself Cartoon Kit*. I thought, "Wow, this is not Hollywood, this is not Walt Disney. This is totally anti-Disney and a funny cartoon." Then I saw *Bambi Meets Godzilla*. That was a revelation. Six drawings and it's hilarious. Must have spent one hundred dollars on it. That's when I realized I didn't have to work for Warner Bros. or Disney to make an animated film.

JB *Do you shoot your films on fours [each drawing held for four frames]?*

BP Yeah, on fours. Sometimes on fives. If it's fast it'll be threes.

Bill Plympton, One of Those Days, 1988

JB *Which animators have influenced your work?*

BP Tex Avery cartoons. I saw them as a kid, but, seeing them as an adult, they really blew my mind. Also the manic Bob Clampett cartoons. I love Disney, the Warner Bros. stuff, *Yellow Submarine*. I was influenced by cartoonists R. Crumb, David Levine, R. O. Blechman, Milton Glaser, Ralph Bakshi.

JB *Any advice for budding filmmakers?*

BP I have a lot of little Plympton-hints. If I were in college or art school today, I would go to work for a big studio for five or six years, for a number of reasons. One, you want to build up some cash reserve, put some money in the bank. Two, you'll learn a lot about the practical side of making films, as opposed to the educational side. You'll learn a lot more techniques. Three, you'll learn how the business works, and you'll also meet a lot of people who can help you and make contacts. Four, you can build a reel of your stuff.

Then I would leave and become an independent animator. My tips there are: try to keep your films short, three to five minutes. Try to keep them cheap—one thousand dollars per minute would be good. And try to make them funny. A lot of films come out that are really beautiful to look at—deep, sensitive, artistic, or political films—but for some reason, I don't know why it is, no one wants to see those films. They want to laugh. And that's been the case from the beginning, people want to laugh at cartoons. That's where most of the market is.

After you've made a film, send it on the film festival circuit—Annecy, Sundance, Cannes—and submit it to the Academy Awards. These four are key. If you get invited to one of these, you'll get invited to thirty or forty other festivals.

So, if you can follow the three rules—keep it short, keep it cheap, make it funny—you'll be a success. The greatest example is *Bambi Meets Godzilla*. Six drawings, cost one hundred dollars to make. He's probably made one hundred thousand dollars on that film. Two minutes long. Another great example is Don Hertzfeldt. He's doing stick-figure drawing for Christ's sake. They're extremely popular.

You don't have to be a great draftsman, but if you are that makes it much easier to sell.

JB *How many shorts have you made?*

BP I would guess twenty-five to thirty, maybe. And I've made two video compilations.

JB *What are your current plans?*

BP My plan is to make a feature every three years and make one or two shorts a year. I supplement that with commercials and an occasional TV special. The shorts make a lot of money. They are quite successful, though not to the extent of *Bambi Meets Godzilla*. *Your Face* cost three thousand dollars and I've made thirty thousand dollars on it over twelve years.

Bill Plympton, Nose Hair, 1994

Mike Judge, **Beavis and Butt-head,** 1992

Below and opposite:
Mike Judge, **Beavis and Butt-head in Frog Base-ball,** 1992

Mike Judge Interview

Mike Judge is the creator (and voice) of MTV's *Beavis and Butt-head* and Fox's *King of the Hill*. He also directed the live-action feature *Office Space* (1999) and appeared in the movie *Spy Kids 2* (2002).

JB *Was* Beavis and Butt-head *your first film?*

MJ No, actually the first film I did was called *Office Space featuring Milton*. That was the first one I animated. I had a tape containing that film and another called *Huh?*, with my Inbred Jed character as the intro, and I just started mailing that out. I started animating in Dallas, on my own, in a vacuum. I didn't know any animators, I just started figuring it out. Spike & Mike had an ad in *Animation Magazine* saying they took submissions, and I mailed a tape in. Spike called me a week later.

He ran *Huh?*, and *Office Space* was picked up by a show on Comedy Central. So I ended up selling my first two films.

Spike called and said, "Make us some more" and "How fast can you make 'em?" I sent him storyboards for one called *The Honky Problem* with Inbred Jed, along with a tape of the soundtrack. And I sent him the storyboard for *Frog Baseball*. Beavis and Butt-head started as that storyboard, actually.

Comedy Central wanted more "Milton's," and Spike was doing the Sick & Twisted show. I was definitely encouraged by him wanting more films. I had drawn Beavis and Butt-head in a sketchbook a year prior to that. Spike didn't go for *Frog Baseball* right away. He gave me an advance to do *The Honkey Problem*. After I finished that, Spike wanted me to do something about the "Thighmaster" commercials. He was, and still is, into this parody thing. I said I wanted to make *Frog Baseball*, how about I just put the Thighmaster on the TV at the beginning. He agreed.

The Sick & Twisted Festival never played in Dallas, and it occurred to me that nobody I know, none of my family members, ever see this festival, so with *Beavis and Butt-head* I thought I'd just get completely out there and do something that seems like it was made by an insane person. I was actually thinking that I wanted it to look like it was made by a madman. I wanted the voices to sound scary and stupid. I thought, what does it matter, no one I knew was ever going to see this.

I got it out of the lab, FedExed it to Spike on a Thursday for his Friday show. He called me Saturday morning and he said it played through the roof.

JB *How did you get involved with animation in the first place?*

MJ I went to UC San Diego and got my degree in Physics. I got an engineering job that didn't last very long—I got a lot of inspiration for *Office Space* and Milton from that. The physics degree did do me some good. Suffering is always good.

I waited until I was twenty-six, just saying I didn't have any connections. I wanted to go into comedy, like sketch comedy, but I had no idea how to do that. Every time you see somebody on TV and they are asked, "How'd you start out?"the answer is always, "Well, I was in a movie called" The story always starts at some level that's completely inaccessible to the guy who's just sitting on his couch.

I was a musician for a long time and I always thought maybe I'll meet somebody who does this stuff. And I always wanted to do animation, but not as a way to break into show business, just because I wanted to try it. I never equated my dream of going into sketch comedy with my work in ani-mation. Two separate things.

JB *Is that your guitar playing in* Frog Baseball?

MJ Yeah, that's all me. Guitar, piano, bass.

JB *What got you interested in animation?*

MJ I wanted to try it since I was a kid. It was always a question of money. My family didn't have a camera. I used to do flip-book animation. I saw some animation in Dallas that a local guy had done: *Scaredy Cat* by Paul Clarehout.

There was also a film in the Animation Celebration festival by M. K. Brown that really inspired me. It was done in colored pencils. She did a comic strip in *National Lampoon*, and I always thought the stuff in *National Lampoon* should be animated. One night I flipped out and said, "There

must be an animation camera in Dallas you can rent time on." So the next morning I opened the yellow pages and called around, and I went to the library and got a book on animation. My big dream was that I'd do a bunch of animated shorts and maybe do some characters on video, and be like a Terry Gilliam and get on a sketch-comedy show.

That's how it started, and *Office Space* was the first one. One thing I like to brag about is that I did all the track reading for the dialogue with a stopwatch from

Mike Judge, `Inbred Jed's Homemade Cartoons,` 1991

that someone working on the show was on the same wavelength and was also really smart, honest, and knew animation. After that we collaborated on the movie.

JB *Did you see a Spike & Mike show when you were a student at UC San Diego?*

MJ Oh yeah, I loved it. It blew my mind. I'm thirty-eight, and I always remember people my age saying that all the good animation was long gone. It was done back in the 1950s. You just assumed there was no good animation anymore, it's all the Saturday morning crap. But then I went to this festival and it blew my mind. Not only was it really good stuff, it was really interesting and it looked beautiful. I wanted to be a part of it—how do you get a job doing that stuff? I would have been happy to just do the music or voices.

I remember Spike handing out flyers, and I asked him, "Who does these films?" He always responded with one-liners, jokes, you never got any straight answers.

I always assumed you had to know somebody, be part of a big production. It didn't seem like anything you could do yourself. For years I thought about getting a camera, in the back of my mind.

JB *And did you ever find a camera stand in Dallas?*

MJ The only animation-camera-stand operator in Dallas had died. I called the place and they asked me, "Do you know how to use one?" I said, "No." And they said, "Do you want to learn how?" I said, "Well, sure." They said, "Why don't you shoot your stuff on it to learn how?" I

my four-track cassette recorder. Created my own exposure sheets. I did the music and the sound effects in advance and animated to it.

JB *After your great reaction to Frog Baseball, then what happened?*

MJ Spike wanted me to do a Robin Leach parody, which I didn't want to do—although I can do a pretty good imitation. Spike suggested putting Beavis and Butt-head at a monster truck show, which

became *Peace, Love and Understanding,* the second one. Those were the only two I animated by myself. After that it was the MTV show.

JB *I understand that setting up the studio to do* Beavis and Butt-head *for MTV in New York was a struggle.*

MJ In the beginning it was a real mess. Tony Eastman and Yvette Kaplan saved my life in the first season. When Yvette Kaplan came in, that was the first time

would have paid anyway, but I saved six hundred dollars, which was then half my bank account.

JB *Memories of attending Spike & Mike shows from your college days?*

MJ It was different back then. They hadn't started the Sick & Twisted shows. Crowded with college students and older people, the NPR crowd. The Sick & Twisted Festival definitely separates out those people from the other types.

Spike and Mike themselves were like bikers, more Charles Manson types than I expected. I expected these animation types to be more dignified looking. The audience behaved as if it were *The Rocky Horror Picture Show*, chanting lines of my film at the screen. It was totally a nerd animator dream to be appreciated. I had gone from never seeing my films with an audience, then to come out here and have that happen was a great thing.

Spike was eager for me to make more films. I told him a story I read in the paper about a woman who was making tortillas for her husband and saw the face of Jesus in the tortillas. Spike said, "Make a film about that." He offered me a check for two thousand dollars and a contract. I still have it. The film was to be called *The Spirtual Tortilla*—but I said I didn't know how to make a film about that.

It's remarkable how many people still come up to me and say they've seen my films at a festival, to see how far-reaching this festival is.

The number of people it reaches is so large. I think if someone in Hollywood really knew the full extent, they'd be making big offers to them. It really does attract a lot of people. I think I'm probably one of the first round of people who grew up watching these festivals, got inspired by them, made a film for them, and gained some success from it.

JB *Who were your animation influences?*

MJ M. K. Brown, Wes Archer, and, of course, Chuck Jones, Tex Avery. I liked a lot of claymation. I tried to do it. The Dallas animator Paul Clarehout (*Scaredy Cat*) did a little short gag film in classic animation—not what I do, but it was inspiring to see a local guy, from my town, doing that stuff.

JB *What would you say to aspiring animators about how to break in?*

MJ It's still the same now as when I started. The thing that attracted me to animation was that it's fairly affordable. It just requires a lot of work. That's how you can separate yourself from other people, because you're willing to do a ton of work. I didn't do anything special. I went to the library and got a book, I ordered some other books. I didn't know anybody. I used to draw but never took it seriously, never thought I'd impress anyone with my drawings. I'd draw faces and get laughs with those.

I shot my stuff on film, drew it on paper. If I were starting out now, I think I'd do the same thing because there is so much computer stuff out there. The stuff that's done on computer and bumped up to film from video—you can tell. When you see it next to something done on film, it's not as rich. You can really separate yourself by doing it on film. Unless you've got high-end Disney equipment, it's not going to work as well as shooting it on film. Especially if you are going into a festival. I think people get too obsessed with the equipment and stuff. *King of the Hill* is still shot on film.

Mike Judge, Inbred Jed, 1991

115

Craig McCracken, Whoopass Stew, 1992

Craig McCracken is the creator of the Cartoon Network's hit series *The Power-puff Girls* and directed a feature-film spin-off in 2002.

JB *Was* No Neck Joe *your first animated film?*

CM The *No Neck Joe* shorts were my first. They were my freshman-year student films that I made at CalArts. They're all hand drawn. I cleaned them all up, then I xeroxed them and spray-mounted them to cels. It was a backward process because I didn't have time to ink and paint, but I could color it in with markers.

I did three *No Neck Joe* shorts my freshman year, as videotaped student films. Spike and Mike came to the Producers Show [the annual CalArts showcase of student animation, open to Hollywood recruiters, executives, and producers], saw the films, and said they wanted to buy them. They paid me to do two more, to run them in their show. So that summer I kind of worked for Spike and Mike and just produced two more *No Neck Joe* shorts on my own. They reshot them in 35mm and put them in the festival.

JB *What inspired the films?*

CM Before I made my film, I went through the CalArts library and watched all the past Producer Shows. I was really inspired by these films made by Rich Moore titled *Ed*. They were these little thirty-second joke films, really funny and really cool. I said, instead of one long film, I'll do a bunch of little ones. So I came up with *No*

Neck Joe. Wrote them, animated them, did all the color, did all the backgrounds.

JB *Then you made* Whoopass Stew?

CM That was my sophomore film; I made that the next year. Spike and Mike again came to the festival, asking, "What do you have this year?" I showed them that and they offered to pay to color it. They played it in the Sick & Twisted Festival, but I don't think it went over as well as the other films, because it really wasn't sick or twisted. I suggested they put it in their regular classic festival, but they wanted more *No Neck Joe.*

JB *How did* Whoopass Stew *become* The Powerpuff Girls?

CM After CalArts I was art directing *Two Stupid Dogs* for Hanna-Barbera and I heard they were looking for new shows. So I went up to the development people, pitched them my bible, and showed them the film. And they said, "Let's do something with this." That was in 1992. Then they started doing the "What-A-Cartoon" program and said it would fit into that.

JB *So the Powerpuffs were no overnight success?*

CM No, it took a while.

JB *Where did you come from?*

CM I was born in Pennsylvania but moved out to Whittier, California, when I was about seven. I essentially grew up in Los Angeles. My dad passed away when I was young. I was raised by my mother. My parents were artists. I grew up in an artistic

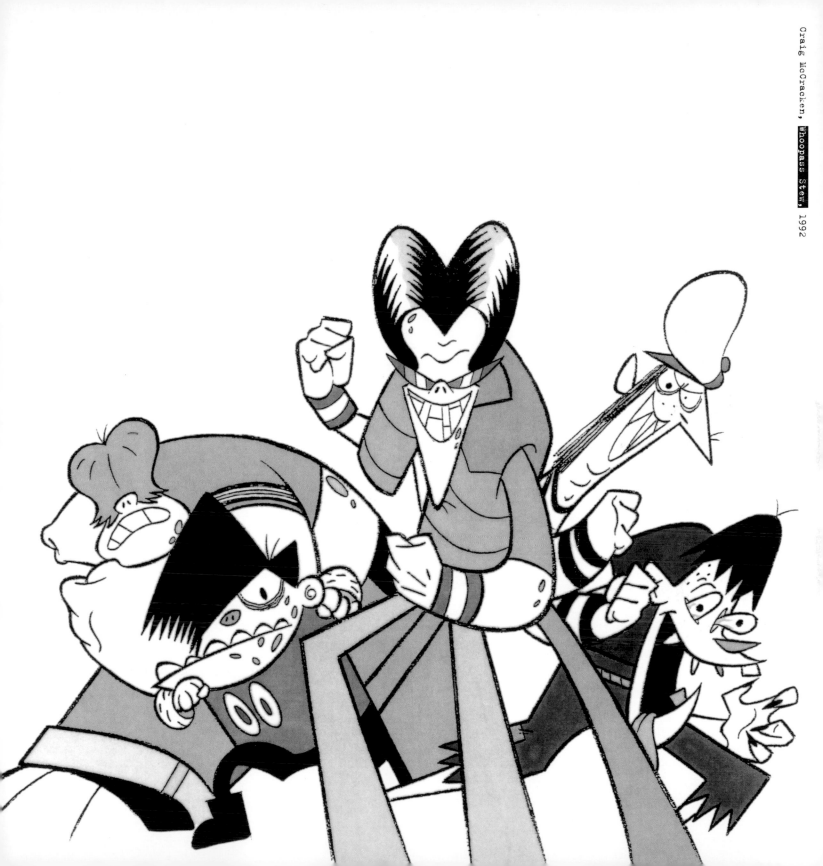

environment. Read comics, watched cartoons.

I was drawing since I was three, but it was when I was twelve that I said I'm going to be a cartoonist professionally. This is what I want to do.

JB *What inspired your drawing style?*

CM Once I knew I wanted to be a cartoonist, I ran the gamut of studying everybody: George Herriman, Floyd Gottfredson, Segar's stuff, Bill Watterson, everybody. I was a huge Tin Tin fan, and I loved *Flaming Carrot Comics*. I went through the whole history of comics and cartooning.

JB No Neck Joe *and* The Powerpuff Girls *have a cute look, with thick outlines, an old-fashioned 1950s commercial look to them. Were you inspired by those old TV commercials?*

CM Yes, I was. When I was a kid I knew that stuff existed but I didn't have a resource for it. I tried to emulate it in my head, but I didn't know really what it was. When I went to CalArts, I found out it was UPA studios, and certain designers did this style, and I learned the whole history of where that style came from. I found all that source material. It was like opening a huge treasure chest. CalArts really opened my eyes to the history of animation and who everybody was.

I didn't know who Tex Avery was until a year before I went to CalArts. PBS had a special on him. I went, "That's the guy!"

JB The Powerpuff Girls *shows an anime influence.*

CM Yes, somewhat, at least in the action sequences. When you try to make a show, you study the best stuff. For humor you study Jay Ward or Warner Bros., for designs you study UPA or early Hanna-Barbera, for action you study anime. They do it better than anybody.

JB *How did you get to CalArts?*

There was a period in high school when I wanted to be a fine artist, a painter, and my parents didn't really want to send me to CalArts to do that. But they knew that animation was what I should be doing, and that the painting I was doing was a rebellion/teenage thing. They were waiting for me to decide to become a cartoonist because that's what I should be.

JB *And you went from CalArts directly into the animation biz?*

CM A bunch of friends of mine were working on the *Two Stupid Dogs* series [Hanna-Barbera, 1993] and they needed an art director. I brought my portfolio down and [series creator] Donovan Cook hired me. It was overwhelming, but I really learned a lot. CalArts taught me the history of animation and techniques, but working on the job really teaches you how to do it, how to make cartoons.

JB *What advice would you give a student?*

CM Always keep going, that's the most important thing. Believe in your own idea, your own viewpoint, and your own style. Don't think you've got to do what everybody else is doing. There is room for originality in the industry. Go to an art school. Going to college was the best thing I ever did.

There are not too many cartoonists around, and I was the only cartoonist in my high school. But then going to a college where everybody's a cartoonist—it's an amazing thing to find all these like-minded people—you'll learn so much just from being around people who are into the same stuff you're into.

JB *Are there independent animators whom you admire?*

CM I went to my first Spike & Mike festival when I was ten. That's when the flyer was a dragon on top of a castle with some wizard, real mid-eighties. It was fun. Those films were certainly inspirations. One of the independent films I've always liked was Joe Horne's, for MTV, called *Stevie Washington*. It's a weird, cryptic spy story about a cool kid on a skateboard. I loved that. It was a model for the first *Whoopass Girls* short.

JB *How would you say Spike & Mike helped your animation ambitions?*

CM When I first went to CalArts I was terrified that I was going to have to do Disney stuff. That's not what I wanted to do, so I went ahead and did my own film. The fact that Spike & Mike bought it, and that there was this great response to it, felt good. I knew I could do what I wanted to. There was a place I could hawk my wares. It encouraged me to keep doing my own thing.

John Lasseter was a Disney character animator who left the studio in the early 1980s to join Pixar in developing the field of computer animation. He went on to win Oscars for his experimental short films and worldwide acclaim for his groundbreaking features *Toy Story, A Bug's Life,* and *Toy Story 2.* Lasseter became personal friends with Spike and Mike shortly after they began distributing his very first computer-animated piece.

JB *What was your first encounter with Spike and Mike?*

JL I always loved animation growing up. I worked at Disney and I followed my dreams of computer animation up here to Northern California. I had just come up here when I saw one of their shows at the Palace of Fine Arts. Probably around 1984. I was working on *The Adventures of Andre and Wally B,* and I went to the Festival of Animation and it blew me away.

I loved the films I was seeing and the chance to see them on the big screen, but I was blown away by the audience. It was the cool, hip people of San Francisco. Young people who didn't have kids. Animation can bring this kind of crowd in. Before I got to know Spike and Mike, and before I had any films in the show, I was really blown away by the kind of people they were getting to attend their festivals. And they made it cool and hip with all this animation. It was fun.

JB *What was your first film in a Spike & Mike festival?*

John Lasseter (Pixar), The Adventures of Andre and Wally B, 1984

JL I think they'd gone to Siggraph in 1984 and picked up *Andre and Wally B.* They showed it and invited me to a show.

I'll never forget the first time I met Spike and Mike. It was in San Francisco, at the Palace of Fine Arts. They invited us down, Bill Reeves [manager at Pixar] and me, they were going to be showing our film. We met them for lunch at Cafe Sport in North Beach. It's the kind of place where the Italian waiters insult you, and basically you go there and they give you a menu, but they don't ever bring you what you order—they just bring you what they want to serve you.

Spike and Mike showed up in full cowboy regalia. Spike had on the ten-gallon hat, the black-and-white cowhide chaps and vest. Mike had on chaps and a hat. They had just been out leafleting on the street—

that's how they market, they literally stand on the corner and hand things out.

And I think that's the year they started getting the little battery-operated moo cows. Spike would leaflet in the financial district or in the hoity-toity areas of San Francisco.

They had balls of steel. Spike had a herd of twenty of these little battery-operated cows, out in front of the Mark Hopkins Hotel, up on Nob Hill, with a big bull whip in his cowboy outfit, leafleting. People had to stop. Spike is huge. He's like a biker who'll beat you up, with the heart of a teddy bear. I just fell in love with these guys right away.

I went to the show later in the week and really enjoyed it. Later they'd fly me down to La Jolla almost every year. I'd always

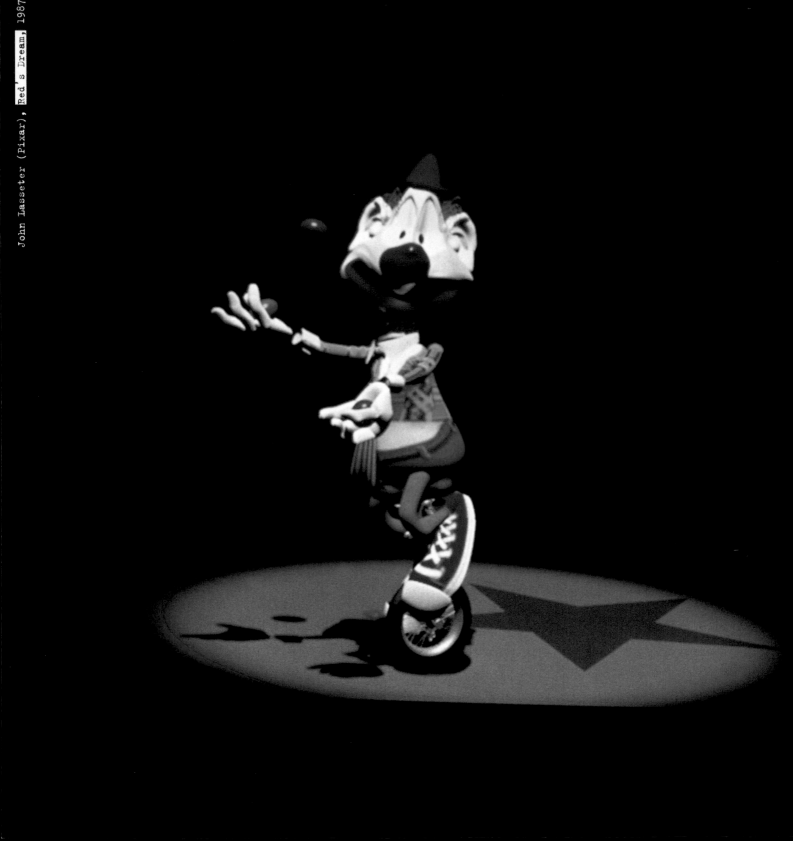

have fun with Spike and Mike and would do all these wild things. They called me "King of Intermission" because I would sit there and sign everything. They had long lines, and they would sell so much stuff. I would do anything for them.

Spike had his little dog, Scotty, who became absolutely legendary because he would pop any kind of balloon. Then they got into inflatable dolls on stage.

JB *What is it about Spike and Mike that appeals to you?*

JL Spike and Mike have the incredible ability to recognize talent and films that entertain, and they put on an amazing show.

And they also keep supporting this incredible art form that no one else is supporting. Especially now.

JB *You became close to Spike and Mike throughout the years. Any memories from hanging out with them at international festivals?*

JL Mike and I traveled a lot together, and we tried to share rooms. But Mike was the worst snorer I'd ever heard in my life. He would just make a house rattle. He would snore so loud. We had to get separate rooms when we were traveling because I couldn't get to sleep with Mike in the same room. I couldn't afford it back then, but I had to.

JB *You were obviously very close to Mike. Did you know anything about Mike's illness?*

JL It happened very fast. We got word that he had cancer. And that hit us so strongly because I had just been to his fortieth birthday party. He did a wonderful thing where he invited Marv Newland and some friends from L.A. to come up, and we all met at the Oakland airport. He rented a helicopter and flew us all over the Bay Area, underneath the Golden Gate Bridge, on top of all this stuff. We ended up at a winery in Sonoma and had an incredible meal in their cellar. One course after another, tasting wine, and we got obliterated. It was so special.

Soon after that we found out he had cancer and was going through treatments. We were playing phone tag, leaving messages for each other. Then I got word that he passed away. He had gotten so weak from the chemo, he had a heart attack and passed away.

It devastated us. We had a housewarming party in which we included a memorial ceremony for Mike. His favorite color was purple, and so we got purple balloons.

John Lasseter (Pixar), Knicknack, 1989

Everybody put little messages to Mike in the balloons and blew them up with helium. Everybody at the party, whether they knew him or not, had a purple balloon. At one point I stopped the party. We all talked about the passing of Mike, a few people told some great stories, then I counted down—and at the same moment, every single person at the party let go of their balloons. It was a really cool thing. I knew Mike would want this, to see hundreds of purple balloons all at once, lifting up as a mass. It was really neat.

John Lasseter (Pixar), Knicknack, 1989

Alison Snowden and David Fine, Pink Komkommer, 1991

Marv Newland Interview

Marv Newland created the classic short *Bambi Meets Godzilla* in 1969. Since then he's been running his own animation studio, International Rocketship, in Vancouver. His subsequent films include *Anijam*, episodes of *The PJs*, and two *Far Side* TV specials.

JB *You started your career in Los Angeles?*

MN The Los Angeles Art Center College of Design, the "training camp" of art. Since then, it has moved to Pasadena.

JB *You didn't take animation classes. You were there as an advertising art student, doing all sorts of things, including film.*

MN They started up some film courses, and I was very interested in motion pictures so I drifted into that area and made a bunch of live pictures. They were all black and white. Actually, no. There was one color picture called *Downtown with Darwin*.

JB *How did* Bambi Meets Godzilla *come to be?*

MN I was shooting a picture called *On Cloudy Days I Sleep In* at the Griffith Park Observatory, and I desperately needed a sunrise. I figured I can always get a sunrise in Southern California. But, as it turned out, it clouded in. For days and days. I panicked, because I had to have this film finished and presented for my graduation. So, I abandoned that picture

and threw together *Bambi Meets Godzilla* on a drawing table. I could always draw cartoons—there was no problem there. I kind of understood how animation worked. I put a Bolex on a tripod, pointed it at the table, and over the course of a couple nights shot the film. So I knew that I had that film if the weather didn't break.

JB *What did you think of* Bambi Meets Godzilla *at the time? Did you think it would become as infamous as it did?*

MN I thought of it then the same way I think of it now. It's a simple-minded joke. I certainly wish I could come up with another simple-minded joke like that. But that's what it was.

JB *So the film you submitted as your class project was* Bambi Meets Godzilla?

MN Yeah.

JB *And did you pass the course with that?*

MN Oh, yeah.

JB *Was it instantly popular with your fellow students and teachers?*

MN The students liked it quite a bit. I was then interested in making movies, so I put it on a reel with *Downtown with Darwin* and another picture I made to go out and try and get work in the movie biz. Most people responded to the cartoon and not to the live action.

JB *How did it go from the school to being known and seen and getting into festivals?*

MN I was trying to get work as an illustrator, that was one reason I went to the

school, and I took it with me to this advertising agency, Chiat Day. The art director there said, "Oh, well, bring your films, we'll look at them." One of the writers at Chiat Day was this fellow named John Amos (who later became a well-known actor) who was working on a local TV program called *The Loman and Barkley Show*. He saw the film and said, "We can't pay you very much, but it'll be fun to show it." I said, "Oh, yeah, what the heck." I was a student, twenty-two years old, and they wanted to put my movie on TV. OK, sure. And they did.

There was a notice board at the art center. And I knew my classmates and my roommates had seen *Bambi* on TV, and they were real practical jokers. So the next day there were all these notes up on the board for me to call NBC and *The Steve Allen Show* and *The Diana Shore Show*. I didn't call them back because I knew my friends were putting them up as gags. In the end it turned out those notes were real, in response to the film being shown on this obscure local TV show. And the picture sort of took off and was shown on all these TV shows. It really didn't go into festivals because, in those days, I didn't know a thing about festivals. I didn't know about independent animation. I didn't know much about animation until I moved up to Canada.

JB *Did you come from Canada?*

MN I was born in Oakland, California.

JB *So, what brought you to Canada?*

MN I wanted to work with the National Film Board. But, I've only made one minute with them, which was in 1978. A real minor vignette.

JB *Can people from the United States and work for the Canadian Film Board?*

MN Lots of people do. I think Caroline Leaf is American. There are a few others. That's the beauty of the National Film Board.

JB *From 1969 to 1975, you went to work for the National Film Board. That was your plan?*

MN That was my aim. But I went to the wrong city, Toronto instead of Montreal. In Toronto, I was plunged into a commercial world and did some *Sesame Street* segments and educational TV stuff. It's a commercial and industry-driven animation scene there.

JB *What led you to Vancouver and starting International Rocketship?*

MN My life in Toronto blew up. I had a falling out with a woman I was with at the time. I came out West, just to see a friend and head down the coast back to L.A. to maybe work for commercial studio, and I arrived here in Vancouver. It was pretty nice. And then, eventually, I just hung out here and did freelance work all over the place: LA, New York, Chicago. I went to Europe to work. Came back here. And then I decided the only way to maintain my roots here was to bring productions to me instead of going out to the productions. So, I set up a little company. To do that, and to also make short films.

Marv Newland, Black Hula, 1988

JB *That was definitely a priority for you, to make some independent films that were yours.*

MN Yes, that was the major priority.

JB *It was your reward for doing all the other work.*

MN We were our own bank. We'd make commercial work and then take money and put it into the independent shorts so we didn't have to go begging to anyone or dough. However, we did have Canada Council grants, DC film money, and things like that.

JB *Was* Sing Beast Sing *one of your first independent films?*

MN Yes, that was in 1980. When *Sing Beast Sing* won the Silver Hugo in Chicago, a jury prize in Annecy, and a Grand Prix in Bellevue, and all these awards, my friend Paul said, "Hey, you gotta make another picture. With your prizes, you can probably get a pretty good grant." I said, "I only have one idea for a film." I told it to him and he said, "That's right up their alley." And they gave me a grant. They gave me half the money that I asked for. So, I went ahead and started the production.

JB *That was for* Anijam?

MN For *Anijam.* [*Anijam* was an eight-minute film that combined stream-of-consciousness cartoon segments, all using the same character, by ten different animators from around the world, each segment linked by the last drawing from the preceding section.]

JB *Did anyone ever do a film like that before?*

MN Not to my knowledge. I've heard of people doing them afterward, like Joanna Priestley.

JB *Well, it was fun. I want to encourage you to do* Anijam 2005.

MN I'd love to. People still approach me and say, "If you ever do one of those again, make sure that I'm on board." Well, we did *Pink Komkommer,* which is in that zone. But I'd really like to go back to the pure idea again.

JB *How did you meet up with Spike & Mike?*

MN I remember meeting them in the eighties. I used to hear about them through [animator] Mark Kausler. He told me that they were running *Bambi Meets Godzilla* at the time. He said, "They're good guys." And, eventually, they became interested in *Anijam,* or *Sing Beast Sing,* or one of the other films. So, they contacted me when they were in Seattle. And I was in Vancouver, so I went down to Seattle to meet them.

JB *And what was that like?*

MN The first time I met Spike was in a motel room in Seattle. Some person, I guess it was Shane Peterson, who was never a choirboy, led me into this room, and there was this big guy lying down on the floor on the phone, with food all around him. Cash money lying around in wads. Flyers and so on. And he was talking on

the phone for about fifteen, twenty minutes while I was sitting around waiting for him. And that's kind of how it's been ever since. I don't think I've ever been in Spike's presence when he hasn't been on the phone for a portion of that time. There he was, much the same as he is today. I was with him in La Jolla on a number of occasions where he wore a red round rubber nose and big, foam-rubber moose antlers. Walked around town, in high-class real estate offices. Passed out flyers and dialogued with people.

JB *What about your first time at one of their festivals?*

MN I think the first time I was at a show was in La Jolla, because I remember being taken over to a motel room right on the coast. Spike reached into his pocket, pulled out a big stack of bills, and paid the hotel room in cash right before my eyes. That was quite funny. Mike, at the time with his purple beard, ran up on stage to introduce me and talk with the audience for a while. Beach balls flying around. I really thought all of this was great. I wanted to tap their energy. I thought the audience really got more than they paid for. I could see why they were going to be successful at what they did.

JB *Tell me about any experiences with Mike.*

MN Mike relished the company, and loved the attitude, of animators. He was really the front man, the person who could go to the all foreign festivals and see films that he liked or that he heard the audience responded to in a big way. Then he would

pigeonhole each of the animators and get the rights to their film. He was amazing. One time Mike phoned me up from France and mentioned he was in Paris at the shop where they sold all of the great Tex Avery statues and lamps and things. And I asked, "Oh, do they have the Tex Avery chessboard there?" So he said, "I'll pick one up for you and bring it back." And I said, "Don't do that, it's huge," in the box and so forth. And he said, "No, that's ok. I'm picking one up for someone else, and I'll bring you one too." And in the end, I found out that he was dragging three of these huge boxes of Tex Avery chessboards through the airport, plus the usual duffel bag he carried around full of t-shirts and squirt guns and things.

We used to have great squirt gun wars here. A lady friend of mine and I were in my VW van driving down Arbuda Street, right past the Ridge Theater here, and we saw the marquee "Spike and Mike show, coming to town." At the next intersection a car pulled up next to us, and the lady in the passenger seat next to me said, "Oh, that looks like Mike in the car next to us." And I happened to have my most powerful squirt gun handy, because I knew those folks were coming to town. And she rolled the window down in the van, and got them to roll down their window. I just fired away, and water got into their car. They sent people in disguise to my studio, carrying an attache case to discuss the possibility of making a little film. And their stooge went into my office, opened his attache case, pulled out a squirt gun, and doused me. So there were these elaborate goings on. Those were great times. You didn't know what was going to happen.

JB *Would you say most people have heard of you because of the exposure in that festival?*

MN In North America, certainly. Anything that people know about my films is through the Spike & Mike Festival. Definitely. *Anijam, Sing Beast Sing,* and the films made in my studio with other directors, like *Dog Brain* and *Lupo the Butcher.*

JB *You mentioned the other films your studio produced. Tell me about that. You had people on staff and you encouraged producing some of their films? How did that come to be?*

MN The first of the films by other directors produced by Rocketship was *Butterfly,* which Peter Muller directed. I produced it in 1983. It was an exercise that we were doing of a close-up character, and I liked the drawing and what was going on. I said, "Why don't you finish it off into a little movie? The thing's practically a minute and a half long now. Take it up to two minutes and we'll make it into a picture." So he did that, and he finished it off and released it. It did all right. It went to Cannes, it went to a number of festivals and had a number of television sales. After that, I thought maybe some other people would like to do that, if I can find some pictures we can make easily and economi-

Marv Newland, Sing Beast Sing, 1980

125

Above and below: Marv Newland, *Anijam*, 1984

cally. This one paid off, maybe we can do some more.

JB *Did that work out with* Lupo *in particular?*

MN *Butterfly* paid for itself and *Lupo* paid for itself, and I believe *Dog Brain* paid for itself. *Lupo* was quite successful.

Lupo was the basis of the Sick & Twisted Festival. They may not admit to that, but I think when they saw the videotape they thought, "Well, we can't show this to a general audience." But, in fact, you could show this to a general audience, and they would go crazy.

JB *Any advice for young, independent animators who want to get into this field?*

MN Well, what I say every time I meet a class in film school is, "When you're young, and you're starting out, it's your opportunity to make whatever you want." The great thing about animation is that if you want to make a movie, you just start making it. The facilities for getting it drawn and made are minimal. It's a desk with a light and that's it. And pencil and paper. Or else make it in some form or other, but make it in frame-by-frame fashion. Animation filmmaking gives you the opportunity to do exactly what you want to do. It's unlimited as far as what you can put on the screen, as long as you can draw.

Don Hertzfeldt Interview

Don Hertzfeldt is the president of Bitter Films. His animated short *Rejected* (2000) was nominated for an Academy Award.

JB *How did you get involved with Spike & Mike?*

DH I grew up in the Bay Area, where the Classic Festival played annually at the Palace of Fine Arts in San Francisco. My parents took us to every show from when I was twelve or thirteen or maybe even younger, and I was instantly hooked on all of these different artful and exotic animations from around the world. They all seemed much more powerful and free than the cartoons I was used to seeing on TV. In high school I remember thinking how cool it would be to have something in the show one day. I sent them my first 16mm film, *Ah, l'Amour*, on a lark in 1995. This was a piece produced as a learning exercise for a beginning production class in film school, never really meant to see the light of day. Spike picked it up, and every year since I've had a new film in the show.

JB *Any wacky Spike & Mike festival experiences?*

DH Yeah, this one is pretty wacky. It happened shortly after the news of the Oscar nomination for *Rejected*. (This is an excerpt from my production journal, from March 3, 2001.) Spike happened to have the Sick & Twisted Festival in town, right here in Santa Barbara, at the Arlington, an old historic theater. It was Friday night and probably featured our most inebriated audience of the weekend. I rephrase: most everyone in there was blitzed out of their

skulls. I decided spontaneously to buy a giant, stuffed floppy rabbit, easily four and a half feet tall, with a frilly bonnet and patterned dress, and I threw it out to the audience to see it get tossed around and crowd-surfed. Bunny lasted about fifteen seconds before it was torn to absolute shreds, stuffing and limbs everywhere.

As *Rejected* began, everyone in the theater was laughing along quite well except for this one sweaty fellow sitting right in front of me, who was sort of just motionless in his chair with a blank expression on his face. Wow, this guy must not like the film very much. Everyone else is laughing and cheering and he's just sort of staring at it sternly. The eye-exploding-blood-screaming scene begins to unfurl, and I see this guy's head and shoulders finally

start to bob and up and down, and I'm happy that he's finally found a scene he enjoys. He continues bobbing and turns to his right, but I see there's no smile on his face . . . blaaarrrrgh, vomit blasts out of his mouth, all over himself and the adjacent empty chair, I change rows. It was the very first time I saw one of my films induce somebody to puke, though I think it may just be the quick editing in the scene that startles our recreational drug friends. We escaped the show alive, retiring to the Irish pub the moment intermission was over. The theater had the Santa Barbara Symphony booked in there for the following evening, and I couldn't help wondering about the variety of discarded bottles, vomit, cotton rabbit stuffing, giant balloon remains, and controlled-substance stains slathered all over the theater as we

Don Hertzfeldt, Billy's Balloon, 1998

watched the oblivious, kindly upper classes of the Santa Barbara fine-arts community file out of their concert in lovely suits and furs.

Spike arrived for the weekend on Saturday and reclaimed the theater late that night. The audience was easily our friendliest of the weekend and nothing was thrown at the screen. Many of the theater seats were now suspiciously draped with plastic sheets. I climbed onto the empty chairs in the front row with another giant rabbit to sacrifice. It actually surfed around for a good few minutes (which, from the back of the theater, pretty much just looks like a boneless, floppy child flying through the air from row to row), before its head was torn off. I believe the head and body were still being separately hurled around the theater well through the first couple of

Don Hertzfeldt, *Ah, l'Amour,* 1995

films. Thank you to Albertson's for stocking their Easter products so damn early. *Rejected* played really well that night and many in the audience sang the praises of the film as being "even funnier than last night!" because they were trying out new drugs. You crazy kids! Spike put a box on his head and continued his practice of writing his name on topless women. The giant rabbit I brought for Sunday saw its ears, legs, and face torn off and worn as trophies. I guess there is a lot of aggression in this town. Anyway, we escaped out the back to our Irish pub at intermission each successive night, and I don't need to drink Guinness anymore for a while, thank you.

JB *How, if at all, has the exposure in the festival helped your career, or the film's success?*

DH Although the films have played all over the world, independent of the festival, the show has always been the most important venue to come home to for us, a dependable tour for the films alongside our other exhibition plans. Any audience anywhere is a blessing for a film, especially animated shorts, which traditionally never get any theatrical release whatsoever at this level. Moreover, the show has not only helped cultivate our own audiences and fans, but it has remained the most reliable place for them to catch our new pieces every year. Sundance and Cannes are great and all, but that's not where your real fans are going to be. A cozy tour plus a dependable audience-in-waiting for your work: I can't think of much more for an artist to ask for.

JB *What are you working on now?*

DH I'm currently up to my neck in nocturnal production on the next short, which was underway before *Rejected* was even completed. And it's likely to be another year before this one will be ready for release. It's the most difficult project I've ever approached in my life and is easily the most visually dense of all our films. It is something that anyone would tell you is impossible to produce without the use of computers, so therefore I simply had to find a way. Viva traditional animation! Unfortunately, drawing absolutely everything on screen over and over again the way I do is not the most thrifty way to produce animation like this, so it's extremely time-consuming and hellish, but ought to be really something special to look at.

Meanwhile I'm still natting around this feature project at the studios, which has

taken a couple of years to finally flesh out. Then, to keep me sane on the side, I've been putting together this very strange comic-booky type of project. A few other projects are being juggled around as well but are still too young to get into. I taught an animation theory course for fun at my old university this summer and that took frighteningly more energy out of me than I had ever thought possible. Respect your teachers, kids!

JB *Do you have any favorite short films in the festival?*

DH I've never really been a big fan of the Sick & Twisted show. I've always had our films participate in that show reluctantly, on the condition that they would simultaneously play with the Classic Festival, which is almost always a great program. Sick & Twisted has never interested me, aside from the one percent of films in that show that actually have something to say. There are just far too many things buzzing around our heads these days that have absolutely nothing to say. So, on that note, my favorite animated short at the moment is *When the Day Breaks* (Wendy Tilby, 2000) because it's so brilliant it makes me nauseous with jealousy.

I've also been a big fan of the underrated Aardman short *Ident*. But I always fall back to live action with my biggest favorites and influences, and in terms of shorts you can't beat *La Jetée* (Chris Marker, 1962) or Truffaut's *Les Mistons* (1957). I sound really pretentious right now.

JB *Have any independent animated shorts influenced you at all?*

DH Despite being exposed to all those international shorts in the festival since I was young, most of my biggest influences are, again, from live action: namely, Stanley Kubrick and *Monty Python*. I think because I saw so many of these animated shorts in the festival growing up, they sort of absorbed into me as a shapeless whole rather than via any one particular artist. All of those classic shorts are probably where I got my eye for timing.

JB *Any advice for budding animators/ filmmakers trying to break in?*

DH The first mistake is in the trying. I can always tell when a film was produced by somebody "trying to break in," because it turns out desperate and bland. Artists should never concern themselves with anything other than their art in the moment, not where they hope it ends up. Otherwise, they stop taking risks, and risks are usually the most interesting bits in the piece, even when they fail. Buy into the concept that there's no such thing as a "bad" creative choice, just ones that you can recognize as being half-assed on a personal level. All you need is access to an animation camera and some paper. If you end up with something special and share it a little, the "business" will break into you, believe me.

Don Hertzfeldt, Lily and Jim, 1997

Peter Lord is the cofounder of Aardman Animation and codirector of *Chicken Run* (2000).

JB *Did you know Mike Gribble?*

PL Our stuff started getting shown in festivals about 1983. I met Mike shortly thereafter.

I met Mike first because he traveled. Spike seemed pathologically incapable of leaving the country at that time. They'd spot films they wanted and you'd make a deal. Which was good for us, particularly in the early days when our stuff wasn't very widely shown in the States. The festival was a natural outlet for our kind of stuff. Mike would be at all the festivals. He would freak out the French waiters at Annecy by looking bizarre, with his purple beard. It took me a while to tune into Mike, but when I did I found him to be a charming, funny, generous guy.

Spike and Mike were great companions. When *Creature Comforts* was nominated we went to the Oscars with them—me, Nick Park, and Dave Sproxton. We were quiet, respectable English gentlemen

Suddenly we went to the Oscars, all this fantastic glamour. Spike and Mike had hired a small fleet of these classic cars, pink Cadillacs and stuff like that. We cruised down Hollywood Boulevard in these classic vehicles. Had the time of our lives, thanks to them.

JB *When did Aardman form?*

PL The name Aardman, which most people find justifiably meaningless, was based on the first thing we sold—a drawn animation that we sold to the BBC—it was a twenty-second movie about a character we called Aardman, like Superman with the tights and the cape. A super Aardvark-man. The name was registered in 1972 and we started working full time, seriously, in 1976. Before then we were students. We did a series of films based on real conversations, starting in 1977, and we kind of strung that idea on for about ten years. In this business you need to do something unique, and we had two things: one was the use of plasticine, clay, and the other

was animating puppets to real sound-tracks so that the clay figures looked like they were having very natural, often quite banal, real conversations. That was a unique combination at the time.

There was some strange magic that went on. By making the animation very carefully and by loving the detail you can really get the puppet acting. The important thing wasn't getting the puppet talking, the more important thing was to get the puppet thinking.

JB *Why did you choose to get into animation?*

Peter Lord, **Wat's Pig,** 1996

Peter Lord, Adam, 1991

Left and below: Richard
Goleszowski, Rex the
Runt, 2001

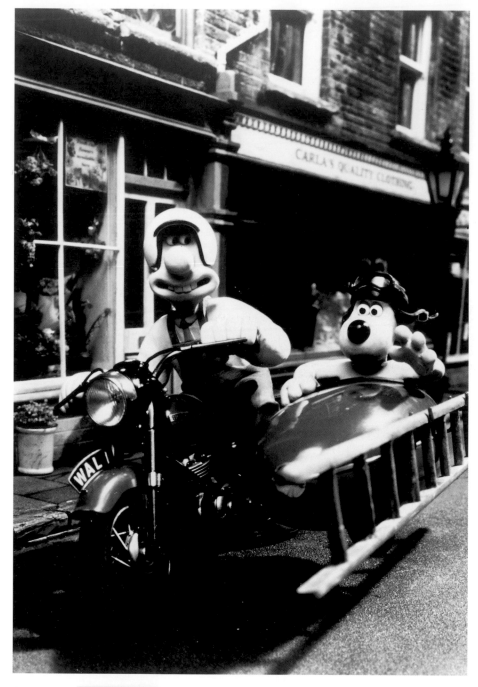

Nick Park, A Close Shave, 1995

Nick Park, A Close Shave, 1995

PT I was a fan, an enthusiast. For people of my generation, there wasn't that much to see. Today there are tons of animated films, and adult stuff. Back then animation was for kids, so you thought. And then you saw stuff like the Warner Bros. cartoons and you realized it wasn't for kids after all. One of my favorite things was the *Rocky & Bullwinkle Show*. I was very inspired by that, thought it was great. I was in school with this guy, David Sproxton, when I was fifteen years old, and we started animating simply because we had a camera. We experimented. Anyone who is in animation will know what a fantastic experience it is artistically, because you create this thing, this performance, from nothing. There's nothing there.

For instance, if you play in a band, you hear the music that you play, then it's recorded and so on. But with animation, there's nothing to see when you are doing it. It's a static process. You creep along all day doing something rather slow and careful; you have a cup of tea, you are listening to the radio, you work away, you get bored and look out the window, work, work, work. When you are finished the next day, there is a moment, a piece of action that you've

totally brought to life, something that never existed. That's an exciting experience. Once you've done it, you're hooked. "That was great, now I must make it better!"

JB *Who else inspired you?*

PL Lots and lots of people. Paul Driessen, he's a fantastic animator. He's got a very weird personal style, but by god he's good. I like Richard Condie—my instincts go toward the funny films. On the other end, Yuri Norstein, a Russian, he is absolutely genius. And at the very edge of weird are the two guys known as The Quay Brothers. They do puppet animation completely different from what we do; it's from another planet. Brilliant!

JB *Did you ever see Gumby when you were a kid?*

PL No, we didn't have Gumby in England. We had "Morph," which was a British version.

JB *Where did Nick Park come from?*

PL Once we'd gone full blown in 1976, we were busy, but it was a bit lean. Things picked up in the early 1980s, so much so that we thought we'd take on some help. We met Nick at the national film school where he was student. We gave a lecture there. Here was this guy who was doing what we were doing, the same kind of stuff. When we met him he was finishing his film, *A Grand Day Out.* So Nick joined us and did odd jobs for us, up to and including making the tea, I suppose. He worked on every commercial project we had. We also gave him the time and the space to finish *A Grand Day Out.*

JB *I always love the attention to the smallest details in your films.*

PL We thought, and we still think, of what we are doing as filmmaking first. The most important thing is storytelling. The sets and lighting should mean something. They shouldn't just be a decoration, they should have an atmosphere.

JB *Are you still using plasticine, or is there now computer-generated imagery involved?*

PL It's still stop motion at the moment. In the studio we do computer-generated imagery. Everyone does these days, it's a fact of life. I like it. But the feature films we are planning are all traditionally done. *Chicken Run* took five years to produce. Our next feature will be out in 2004.

JB *You are making features now. Are you still planning any shorts?*

David Sproxton, Morph, 1995

PL We are doing *Angry Kid*, which Spike & Mike have played, for the Internet. We have a couple of Internet and TV series in development, and commercials. So it's not just features.

Nick Park, Creature Comforts, 1989

Danny Antonucci Interview

Danny Antonucci is the creator of Cartoon Network's *Ed, Edd n Eddy,* MTV's *The Brothers Grunt,* and the infamous *Lupo the Butcher.*

JB *What do you think of Spike & Mike's Festival of Animation?*

It's great. They took the traditional animation festival experience on the road. So instead of people having to go to Annecy or Ottawa, they can have it come to them.

JB *Have you been a guest at the festival?*

Oh yeah. The first time was in La Jolla. I stayed at Spike's house because they were too cheap to get me a hotel room. So I had to put up with Mike snoring and Spike's complaining. It was fun.

Marv Newland and I made many appearances at the festival when Spike & Mike came to Vancouver. We'd have our water-gun wars. One time we got dressed in commando outfits. Me, Marv, Dieter Mueller, and J. Falconer—all of Marv's International Rocketship crew—we'd have a multitude of water guns and we'd hide under bushes until they got home from the festival and bombard them. It was an ongoing thing.

I remember one time Gribble was doing a TV interview at Rocketship, and during the interview he got soaked with water guns.

JB *How did* Lupo the Butcher *come to be?*

DA I had just started working at International Rocketship, been there a year or so. I had worked on kid shows for so long. You have to remember I started in animation in 1979, which was probably the worst era for animation. I was doing Hanna-Barbera work, *Scooby Doo, Flintstones, Smurfs, Richie Rich* in Toronto, doing all the key animation at a subcontract house.

I ran away—I said, I can't do this anymore. I was headed to L.A. but ended up stopping in Vancouver to see a friend. The second day I was here I got hired over at Rocketship.

I was working on Marv's kids' safety film *Hooray For Sandbox Land.* And I was thinking, here I am working on more kid stuff. As frustration grew, I just wanted to do something for myself. It was more a rant than anything else. I also wanted to create a character.

I boarded the film—and the storyboard was a lot different than the final film—and Marv didn't know how I was going to do it. I told him I wasn't doing it for anybody, I was doing for myself.

I had just started working on it and I was pretty passionate about it. I had no money but I was doing it anyway. Marv at some point offered to produce it. He said, "I'll cough up all the fees for the film and paper." So I started and it snowballed.

JB *Was the dialogue improvised?*

Danny Antonucci, Meat the Family, 1989

DA No, it was totally scripted. Every "God damn son-of-a-bitch," believe it or not.

JB How long does it take for a film like this to get made?

DA It took me a year and a half to make it. Bill Schultz inked it all for me, the cel painters at Rocketship colored it.

JB Did you have a premiere party for the film?

DA Oh yeah, it was at the Ridge Theater, a grand old theater in Vancouver that Spike and Mike would always use for their shows. It premiered at the regular screening of an art feature. Our premiere was like a tester for Spike and Mike because they happened to be in town and they saw the audience reaction.

JB What was the initial reaction to Lupo the Butcher?

DA Spike and Mike were totally fearful of *Lupo* in the beginning. It was Marv who talked them into playing it. They ended up getting a lot of complaints about it, so they stuck it in the midnight show as a bonus.

JB How long were you with Marv's studio following the making of this film?

I was with Rocketship for thirteen years. I left when I got the *Brothers Grunt* series with MTV. I figured it was time to start my own studio, A.K.A.

JB Everyone in Vancouver is so supportive, you never seem like competitors.

DA We're not competitors. We are such individual studios that we don't compete.

We're not bidding on the same jobs. All our work is self-motivated. Even with my commercials, I have a client who comes to me.

JB How many episodes of the Brothers Grunt *series were produced?*

DA We did forty-five seven-minute cartoons. It was a weird show, purposely set up that way. I wanted to do a very surreal show. I was fooling around with all sorts of things, with design and story—a total experiment. MTV was cool with it. The ratings weren't there. There were so many factors. I still get mail from people who want to see more Grunt.

Everyone had been labeling me as this adult animator, then *Ed, Edd n Eddy* came up and my motivation was to go in the opposite way. After *Ed, Edd n Eddy* I may swing back around. I've been working on a feature for the last seven years—a horror feature. I'm writing it.

JB Where did you go to school?

DA Sheridan in Toronto. I had the weirdest course in how I got to where I am. Really bizarre. In grade nine, when I was fifteen, I went to take an animation course on a Saturday afternoon. It was one of those little extra classes. And I fell in love with it. And I did this short little film, *The Adventures of Barf Man.*

JB Thus setting the course for your career.

DA He was a comic-book character I was drawing since high school. His barf would solidify in seconds so he could make walls and "barf balls," that kind of stuff. I fell in love with animation and knew it was what I wanted to do. I took a year after high

school, taking odd jobs and building my portfolio so I could get into Sheridan.

Got into Sheridan. There was this group of people there who didn't believe what was going on at the school because the school was Disney's spread. We didn't like Disney, we liked Warner Bros., Fleischer, and the others. I quit after the second year because I had been hired as an animator by a company in Toronto.

That's when I was involved with the Hanna-Barbera work. For two years we would get layouts from L.A. and do all the animation in Toronto, and then send it to Korea for ink and paint and camera.

JB That was your real animation education.

DA It really was. Actually, it was cool, because first off it really helped me learn the process. It taught me how to get my hands dirty in this thing, the whole nitty gritty of animation, which I love. I adore it. Even *Ed, Edd n Eddy* is set up old world. The kids on my crew are getting a hardcore lesson in animation. And with it we are getting a massive turnover. We weed out the wimps and have all these hardcore animation folks.

Even *Lupo—Lupo* I did with cutting mag tape, sixteen reels of sound—we were still splicing and cutting and pasting.

We still hand paint our show. Our show is still hand-inked. Korea at first scoffed at it, but now they like it. It looks cool.

The bad part of the H-B gig was learning all the shortcuts. It was horrible. I didn't want to get caught up in that stuff, so that's

why I was going to go down to L.A. I wanted to go where they were really making cartoons. I'm glad I never made it. Even at that time no one was really doing anything there.

My whole upbringing in animation has been on the rough road. Like a band going out and paying their dues. I totally accepted that. It was cool. There was no instant star status, no massive paychecks. Everyone who was in animation then was in it because they loved it.

JB *What are your influences? Any current filmmakers that inspire you?*

DA I looked at the artists in the festivals as peers. I don't think I was influenced as much as motivated. I was motivated to do more things. My influences come from the older studios. Fleischer Studios. I still look at their work and go, "Cool!"

I think the main thing is capturing the soul. And that's constantly my goal. Not technique, it's not how fancy or glitzy, or what camera effects—it's none of that stuff. It all has to do with capturing the soul. The old guys did that. You look at Popeye or Betty Boop, there's a person behind that. And Warner Bros. achieved that. You've got totally independent directors, animators, all carving their own little niches in those cartoons. It's all because of the person, not the character—the character is constant—it's the person making changes in that character. That thing you just don't see anymore. That gets me cooking.

In the independent scene, with the Spike & Mike shows, you have got to see the technique part of it. Everyone was fooling around with stuff like paint on glass,

markers, clay, and crayons. Much to Lasseter's chagrin they would play that pencil test of his [*Lady and the Lamp*], but it was great because it had soul. The audience thought it was a cool new style, but it was a pencil test.

JB *Any advice for aspiring animators?*

DA When I hire people at the studio I tell them, "Forget about everything you've always done and give me what you've always wanted to do." I'm hiring someone because they're an artist. Explore the art form and never take "no" for an answer.

You need to make a film because it's a way of finding out who you are what your limi-

tations are. It helps you in the sense of growing. But I think in order to make your own film you need the drive and you need the heart. If you are looking to animation as "a career," I don't know if that's a good thing. I think you need to look at it as "a life." It has to be part of your life.

You've got every Tom, Dick, and Harry doing his net cartoons, and that's cool. But the way I look at it is that I can never get enough. I don't know what my goal is—I really have no goals—my thing is a constant drive to understand the art form. That's all that keeps me going.

Danny Antonucci, Lupo the Butcher, 1987

Andrew Stanton interview

Andrew Stanton codirected Pixar's *A Bug's Life* (1998) and has written and directed *Finding Nemo* (2003).

JB *How many films did you have in the Spike & Mike Festival?*

AS Two films. *Somewhere in the Arctic* (*Eskimos & Polar Bear*) and *A Story* (aka *Randy the Killer Clown*). I remember that at the time Juliet Stroud, who did *Snookles*, and I were the first virgin students wooed in: "Here, give us your film and we'll give you money to have it colorized, and we'll put it in the festival." We were sort of the test beds. And it went so well that they continued that habit from then on.

But I remember they were kind of cautious when they came to CalArts in 1987 to see the Producers Show. They approached a few of us. Juliet and I took the offer.

Spike and Mike were really the matchmakers directly for John [Lasseter] and I finding out about one another.

JB *So how exactly did the festival connect you to your career at Pixar?*

AS I went up to San Francisco to appear at a show my films were in, the same program that *Red's Dream* was in. That's how I met John. We didn't necessarily hit it off like buddy-buddy, but we would always have a good time. John is the life of the party, and I was certainly at my height of that phase too.

Somewhere in the Arctic made it in the festival one summer, for 1987, and then *A Story* got colorized and came in the next year, so I went up a second time. And by then John had met his fiancée Nancy (now his wife), who was working for Apple. And Apple wanted to make its first short film on the Mac, and they wanted John to advise them, but he was too busy making *Tin Toy*. They asked him if there was anybody he could think of who could do consulting for them. And he thought of me.

I said sure, I wasn't working at the time. I had just finished up Bakshi's *Mighty Mouse* and was in a dry spell. Apple offered to fly me up to Cupertino for the weekend and talk to them. I ended up having dinner with Nancy and John, and did a brainstorm session on this pencil test. We actually did show it in the festival. And I think that's where we got to meet each other creatively, and we liked how we each worked as artists.

I didn't hear from John again for another year and a half. I thought that was it. Then I got married. My wife moved out from the East Coast. We had a rough three months

Above and below: Andrew Stanton, *Somewhere in the Arctic,* 1987

in Los Angeles. She couldn't stand it. I said, "Honey, I don't know what I'm going to do. This is where animation is." And I even said, "There's this place called Pixar, I don't know if they even make money." And the very next day John called me and said, "I finally got money to hire a second animator. Do you want to come up?" I said "yes" right on the phone. We loaded up the car and moved out—and never looked back.

JB *Are you still married?*

AS Yep! Saved our marriage, I think. So there is this direct relationship and continuing involvement of the Spike & Mike Festival in my career. I really can't exclude it from the happy design that worked out for me.

JB *Let's backtrack. What led you to CalArts?*

AS I just always thought animation was cool. I could always draw. I was very much into acting, very much into music. I was into filmmaking with my friends, super 8 and all that stuff.

But when I got down to it, I enjoyed it but I didn't see anyone getting a job in it. My guidance counselor in my high school had a brochure for CalArts and for the character animation department. You hear the same thing from everyone: "Wow! There's a school that teaches you how to animate?" I didn't think you could anymore. All I see are these white-haired guys being interviewed for Hanna-Barbera. Once I saw that it was an actual place it became a goal, really late in high school. I ended up not getting in my first time. I actually have my rejection letter and my acceptance letter from the next year. I went to this Hartford Art School, which was great for foundational art. I think I was the best student they ever had because I was so driven to get out of there and get into CalArts.

I come from a small New England town, seventy kids in the whole high school, and I was "the artist," right. I didn't know there were other people like me. I get to CalArts and its like we were all cut out

of the same cloth. Some of that's humbling, and some of it is invigorating. Within a week, I realized it pulled in all the things I'm interested in. Filmmaking, acting, music, timing, laughs, comedy—all in this great school where you barely have to study.

Once I got there, I knew this is what I wanted to do. I don't think I knew that so well until I got there.

JB *Were you a big Warner Bros. cartoon fan?*

AS I was all that. But I'll be honest, my biggest entertainment instincts come from *Monty Python* and *The Muppets*. I was born in 1965 so I was in the first generation to watch *Sesame Street*, which was much more irreverent then, with little human-being puppets saying very ironic things, and I really glued to that. We had WGBH in Boston, which still is the hub of PBS, and they were the first people to air *Monty Python*. So at age seven I'd sneak downstairs when my parents were asleep and I'd watch this show, with bare breasts and naughty words, and really funny humor. I really think that was a huge influence on my entertainment tastes.

But I went to every Disney movie, memorized them by heart. I'd sit through the Lawrence Welk Show waiting for it to end so I wouldn't miss an inch of the Disney show. Everytime they'd have that little collage opening, and they'd show just a little bit of animation, I'd go, "please let it be animation tonight," then there'd be some friggin' *Paco, the Wet-Back Hound*—"No!"

I realize when I look back that I had the bug as bad as anyone else. I just had writ-

ten it off so early in my youth that that it wasn't an achievable job.

JB *Animation was dead back then.*

AS And when you're on the East Coast, you don't even have an inkling that there are companies that exist that do animation.

JB *How did you find Spike and Mike?*

AS They found us. I never knew they existed. I remember it was Rich Moore who was telling me, "You gotta hear about these guys Spike and Mike. . ."

I remember getting my first call from Spike. First of all, "Spike?" What the hell, that was the weirdest name to hear. Then you get that voice on the phone. So I heard him first. Your first impression of the manner of his speech and his cadence is so different from how you interpret it once you meet him. I pictured a "Lurch," I pictured a guy with no sense of humor. He has such a monotone droll. Boy, this is "Mr. No Fun."

And it's the exact opposite when you meet him. He had the chaps, he had the cowboy hat, he had Scotty. Your whole world just turns upside down in about five seconds. I met Spike and Mike at school. They had come up to basically wheel and deal.

We used to do caricatures of them dangling McDonald's lunches in wrapped bags in exchange for your canister of film.

JB *They were living cartoons.*

AS They were! I always thought it was fun and games, but then in 1987 I went to Annecy, and Mike started to introduce me to all these people. My film was in compe-

tition. Then he proceeded the rest of the week, "You got to make sure you meet this person, here's Jan Svankmeier, you gotta meet this guy." When we went out to dinner I got to meet the Aardman guys and all these other people. He told me about things I would have not known to do or people to meet. And it was then I really got a sense of how much he was looking out for me. I really had a special bond with both of them, but particularly Mike at times.

They loved to party. They almost put more value on having fun while putting on the show, and getting ready for that weekend, then the actual show itself.

JB *What would you say to a student about breaking into the business these days?*

AS John [Lasseter] has always believed this, and I know I'm saying his line, but you can tell a good animator with anything. It's not dependent on the medium itself. If you've got the cinematic, acting, artistic, and staging skills, all those things, you can do with anything. If you've got the ability to see past whatever medium they are using, then that's the value. You can teach anybody the tool. That's always been the thinking here at Pixar. I would never tell a kid, even today—regardless of the state of 2-D vs. 3-D—to stick to a certain medium. I would certainly say, hey learn anything you can learn. But the biggest thing is, if you don't want to be a cog in the system, you've got to be able to show what you can do with any limitations that you've got in front of you, whether that's pencil and paper, matchsticks, or whatever. The tools you can have today. You can buy a DV camera, Final Cut, or I-Movie on your iMac at home

and you can do movies that look better then some things that are professional. Gee, if I had those tools. . . .

The best thing about the festival format is that you get to be seen as an individual: "Here's what I do, left to my own devices." And that's the best calling card you can have. When I have to hire somebody, if I can see their film, not just the great credentials of what they worked on, that's invaluable information. Even if your film isn't so good, it's saying, this is what you think, this is how you work.

It's my short films that saved my butt, because John saw those finished things, all the aspects of filmmaking, and thought, "I like that guy's sensibilities." He was the first guy who didn't hire me as a cog, as a number to fill the labor force. He hired me for Andrew Stanton. He got my allegiance two hundred percent from day one. Then it was just commercials. There was no *Toy Story*, no promise of anything, I didn't even know if I'd like working with computer graphics—but I loved the idea that somebody wanted to hire me for my sensibilities. And it would have never happened if I had not had a short film, in a format that I could show to the outside world.

Andrew Stanton, A Story, 1986

Flyer art by Cordell Barker

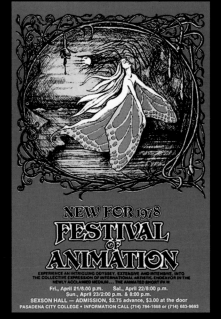

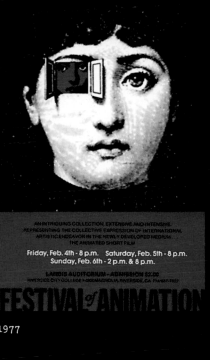

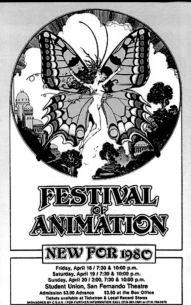

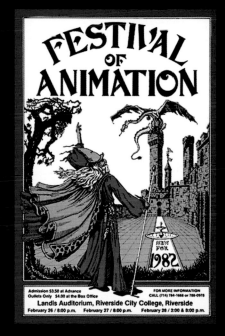

1977

Frank Bambara, 1978

William Stout, 1979

William Stout, 1980

William Binkley, 1982

Cathy Hill, 1983

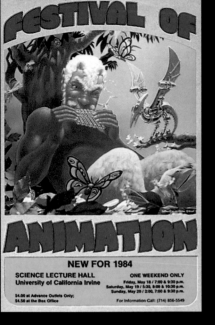

Thomas Warkentin, 1984

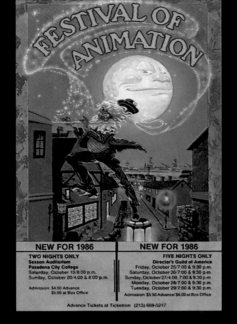

Chris Miller, 1985

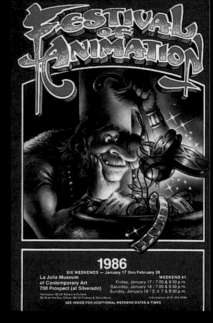

John Pound, 1986

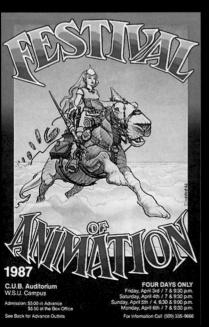

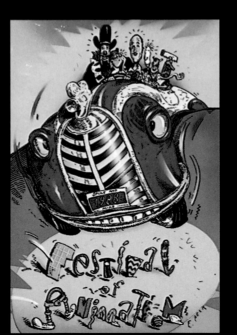

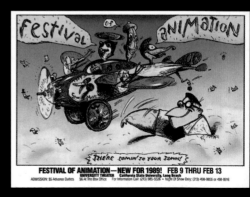

Everett Peck, 1989

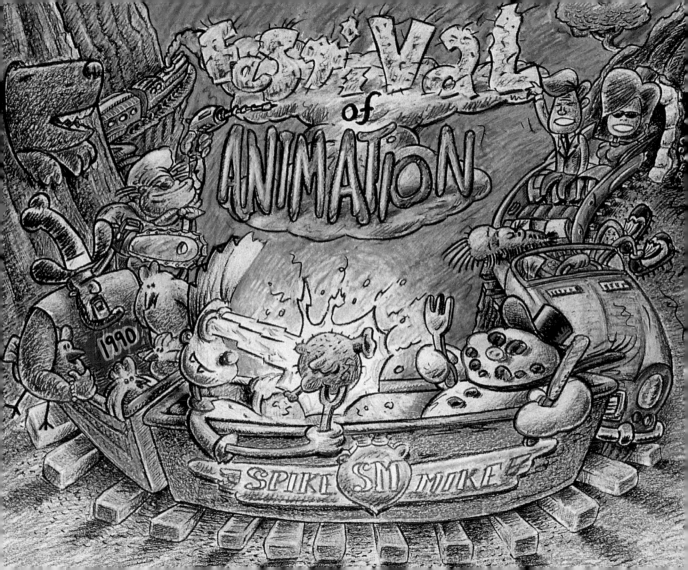

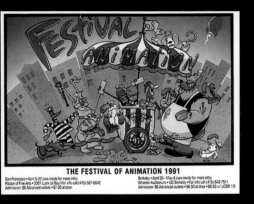

Chris Miller and Dave Wasson, 1991

Everett Peck, 1992

Everett Peck, 1993

Marv Newland, 1993

Nick Park and Michael Salter, 1994

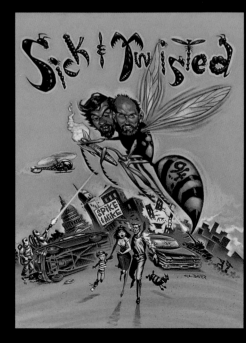

Glenn Barr, 1994

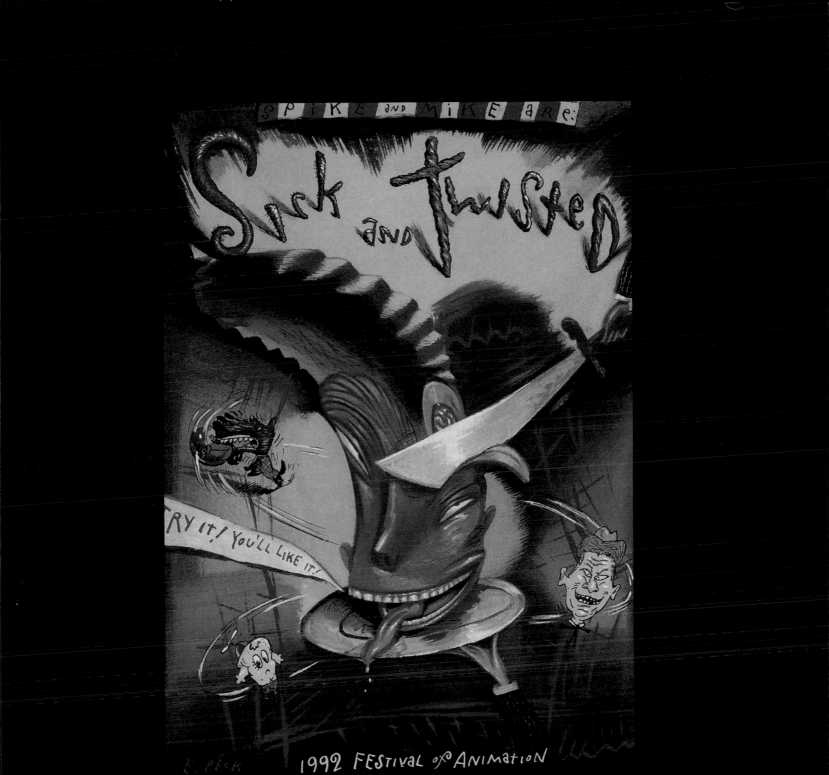

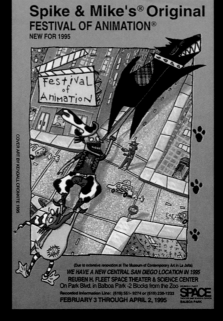

Everett Peck, 1995

Kendal Cronkhite, 1995

Kendal Cronkhite, 1996

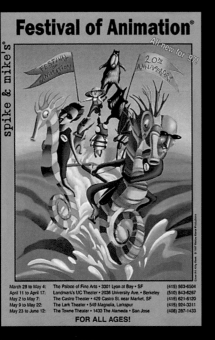

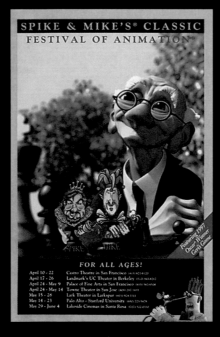

Kitty Meek, 1997

Jan Pinkava, 1998

Robert Williams, 1998

Kirsten Ulve, 1999

Scott Leberecht, 1999

Green & Read, 2000

Gan & Emek, 2000

William Stout, 2001

Firehouse Kustom Rockart Company,

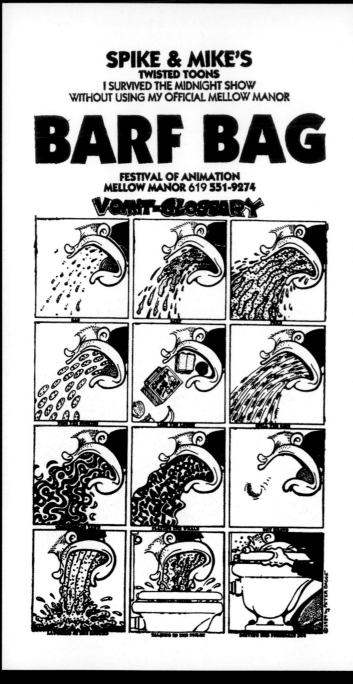

FiLMOGRAPHY

A complete listing of films in each
festival by year, with directors' credits

1977
Rainbow Pass, Gary Demos
Walking, Ryan Larkin
Cannibus, John Kimball
Big Yellow Taxi, John Wilson
Deluge, Larry Schulte
A Phantasy, Norman McLaren
K-9000 A Space Oddity, Robert Mitchell and
 Robert Swarthe
Frank Film, Frank Morris
Bad, Bad Leroy Brown, John Wilson
The Critic, Ernest Pintoff
Betty Boop in Snow White, Dave Fleischer
Superman in the Mummy Strikes, Isadore
 Sparber
Tour d'Ivoire (Ivory Tower), Bernard
 Palacious
Sysiphus, Marcell Jankovics
Closed Mondays, Will Vinton and Bob Gardiner
The Box, Fred Wolfe
Bambi Meets Godzilla, Marv Newland

1978
Cage, Frank Bambara
A Unicorn in the Garden, Bill Hurtz
Chapter 21, Tim Landry
Tubby the Tuba, George Pal
Opera, Bruno Bozzetto
Sandcastle, Coe Hoedeman
Mindscape, Jacques Drouin
The Street, Caroline Leaf
Moon Bird, John Hubley
Vicious Cycles, Chuck Menville and Len Janson
Chow Fun, Sally Cruikshank
Rapid Eye Movement, Jeff Carpenter
Kick Me, Robert Swarthe
Head, George Griffin
Truck Stop, Tim Brennan
**I'll Be Glad When You're Dead, You Rascal
 You,** Dave Fleischer
Cocaboody, John Hubley

1979
Allures, Jordan Belson
Step by Step, Faith Hubley
Furies, Sara Petty
Syrinx, Ryan Larkin
Superman, Dave Fleischer
Commitment, Yoji Kuri
Melon Madness, John Wokuluk

Union, Stephen Beck
The Do-It-Yourself Cartoon Kit, Bob Godfrey
Evasion Express, Francis Masse
Bead Game, Ishu Patel
Moonshadow, Errol LeCain
Jimmy the C, Jimmy Picker

1980
Sonoma, Dennis Pies
Mountain Music, Will Vinton
Animato, Mike Jittlov
Betty Boop for President, Dave Fleischer
Zbigniew in Love, Erin Libby
Neighbors, Norman McLaren
Special Delivery, Eunice McCauley
Satiemania, Zdenko Gasparovic
David, Paul Dreissen
Room and Board, Randy Cartwright
Mechanical Crabs, Zagreb Studio
Why Me? Janet Pearlman
Canned Performance, Hoyt Yeatman
Swing Shift, Mike Jittlov

1981
Daydreams, George Chiatras
Superman in Volcano, Dave Fleischer
Sing Beast Sing, Marv Newland
Self Service, Bruno Bozzetto
Betty Boop's Penthouse, Dave Fleischer
Log Driver's Waltz, John Weldon
Opens Wednesday, Barrie Nelson
Wizard of Speed and Time, Mike Jittlov
Powers of 10, Charles and Ray Eames
It's So Nice to Have a Wolf Around the House, Paul Ferlinger
Legacy, Joan Gratz
Keep Cool, Barrie Nelson
Never Kick a Woman, Dave Fleischer
The History of the World in Three Minutes Flat, Michael Mills
Every Child, Derek Lamb

1982
Elbowing, Paul Dreissen
Goonlans, Dave Fleischer
Crac, Frédéric Back
Creation, Will Vinton
Seaside Woman, Oscar Grillo
The Fly, Ferenc Rolusz
No No Pickle, John Wokuluk
Fish Heads, Barnes & Barnes
The River, Katja Georgi
Betty Boop's Rise to Fame, Dave Fleischer
Canned Performance, Hoyt Yeatman
Dinosaurs, Will Vinton
Magical Maestro, Tex Avery

1983
Currents Caprice, Steve Eagle
Claymation, Will Vinton
Beginnings, Clorinca Warny
Passages, Rowena Pahee
Ballet Robotique, Bob Rogers
Syrinx, Ryan Larkin
The Great Cognito, Barry Bruce
Eyepiece, Michael Long
Make Me Psychic, Sally Cruikshank
Hokusai, Tony White
Betty Boop in Snow White, Dave Fleischer
Fracus, Timothy Hittle
Suit of Many Crayons, Kevin McCracken
The Three Knights, Mark Baker
Animalia, the Cat, Tybor Hernadie
Evasion Express, Francis Masse
Bead Game, Isu Patel
Genius of Love, Annabel Jankel and Rocky Morton
Sandcastle, Coe Hoedeman
Tango, Zbigniew Rybczynski
Reagan Meets Godzilla, Peter Wallach
Brush Strokes, Sylvie Fefer
Self Service, Bruno Bozzetto
Vincent, Tim Burton and Rick Heinrichs
Sunbeam, Paul Vester

1984
Romeo and Juliet, Vera Vlajic and Dusan Petricic
Papa Do Ron Ron, Spitting Image
The Sweater, Sheldon Cohen
Acting Out, Al Sens
The Importance to Participate, Laboratorio Lanterna Magica
No No Pickle, John Wokuluk
Real Inside, John Weldon
Anna and Bella, Borge Ring
Gumby, Art Clokey
Oh What a Knight, Paul Driessen
Dr. DeSoto, Michael Sporn
Creation, Will Vinton
Accidents Will Happen, Annabel Jankel and Rocky Morton
Charade, Jon Minnis
Vincent, Tim Burton and Rick Heinrichs
Anijam, Marv Newland

1985
Puppy Does the Gumbo, Catherine Hardwick
Accidents Will Happen, Annabel Jankel and Rocky Morton
Lunch, Casba Varga
Real Inside, John Weldon
Anijam, Marv Newland

Paradise, Isu Patel and George Unger
Sing Beast Sing, Marv Newland
Dr. DeSoto, Michael Sporn
Oh What a Knight, Paul Dreissen
Spitting Image, Spitting Image Ltd.
Charade, Jon Minnis
Anna and Bella, Borge Ring
Creation, Will Vinton

1986
Land, Sea, and Air, Paul Driessen
Spinolio, Derek Lamb
Every Child, Derek Lamb
And She Was, Jim Blashfield
Pies, Sheldon Cohen
Legacy, Joan Gratz
De Karakters, Evert de Beijer
Pig Bird, Richard Condie
Bartakiad, Oldrich Haberie
Amazing Bone, Michael Sporn
Elbowing, Paul Driessen
Voices, Joanna Priestley
House Cats, Peg Moudy
The Big Snit, Richard Condie
Snookles, Juliet Stroud
Criminal Tango, Solwieg Von Kleinst
Vantz Kant Danz, Will Vinton
The Adventures of Andre and Wally B., John Lasseter
Hot Stuff, Zlatko Grgic
Second Class Mail, Alison Snowden
Quasi at the Quackadero, Sally s Cruikshank
D.J. the D.J., Bob Clampett
Happy Hour, Brett Koth
Hooray for Sandboxland, Marv Newland
Broken Down Film, Osamu Tezuka
Charade, Jon Minnis

1987
The Fly, Ferenc Rofusz
Voices, Joanna Priestley
Sing Beast Sing, Marv Newland
The Great Cognito, Barry Bruce
Tango, Zbigniew Rybczynski
Anijam, Marv Newland
Luxo Jr., John Lasseter

1988
Oh, Dad, Jonathan Amity
George and Rosemary, Alison Snowden and David Fine
Furies, Sara Petty
Face Like a Frog, Sally Cruikshank
Traveling Light, Jane Aaron
Crushed World, Boyo Kanev

Computer Animation Tribute, Various studios
Tango, Zbigniew Rybczynski
Rope Dance, Raimund Krumme
A Story, Andrew Stanton
That's Not the Same at All, A. Fedulov
Somewhere in the Arctic, Andrew Stanton
Hello Dad, I'm in Jail, Christoph Simon
Your Face, Bill Plympton
The Big Snit, Richard Condie
Bambi Meets Godzilla, Marv Newland

1989
Nitemare, John Lasseter
The Thing That Lurked in the Tub, Dave Wasson
Les Assasins, Frederic Vitali
Winter, Pete Docter
Wednesday Eve of Tuesday, Hristo Topuzanov
Tower of Babel, Rastko Ciric
The Cat Came Back, Cordell Barker
The Door, N. Shorinsa
Dog Brain, Jay Falconer
Earth to Doris, Christoph Simon
Primiti Too Taa, Ed Ackerman and Colin Morton
Nice Day in the Country, Christopher Hinton
Lea Press on Limbs, Chris Miller
Tin Toy, John Lasseter
How to Kiss, Bill Plympton

1990
The Crow and the Canary, Arnie Lipsey
All Alone with Nature, Alexander Fedoulor
Black Hula, Marv Newland
The Housekeeper, Brett Thompson and Ian Gooding
Palm Springs, Pete Docter
Uncles and Aunts, Paul Driessen
Chairs, Sandy Kopitopoulos
The Hill Farm, Mark Baker
Plaid Baker, Steve Mealue
Computer Tribute, Steve Goldberg and Sio Benbor
In and Out, David Fine and Alison Snowden
The Chore, Joe Murray
Feet of Song, Erica Russell
Negative Man, Cathy Joritz
Family Dog, Brad Bird
Knickknack, John Lasseter

1991 (BEST OF THE FEST)
Betty Boop in Snow White, Dave Fleischer
One of Those Days, Bill Plympton

Jumping, Osamu Tezuka
Mother Goose, David Bishop
Furies, Sara Petty
The Sweater, Sheldon Cohen
Second Class Mail, Alison Snowden
Tin Toy, John Lasseter
Somewhere in the Arctic, Andrew Stanton
Frank Film, Frank Mouris
Sunbeam, Paul Vester
Jimmy the C, Jimmy Picker
Getting Started, Richard Condie
Anna and Bella, Borge Ring
Happy Hour, Brett Koth
Lunch, Casba Varga

1992 (BEST OF THE FEST)
The Log, S. Kushevrov
Danny Goes Airsurfing, Lance Kramer
A Story, Andrew Stanton
The Housekeeper, Brett Thompson and Ian Gooding
Crushed World, Boyo Kanev
Grasshoppers, Bruno Bozzetto
Vincent, Tim Burton and Rich Heinrichs
A Grand Day Out, Nick Park
The History of the World in Three Minutes Flat, Michael Mills
25 Ways to Quit Smoking, Bill Plympton

1992 (SICK & TWISTED)
Peace, Love, and Understanding, Mike Judge
Empty Roll, Miles Thompson
In a Pinch, John A. Davis
Thanks for the Mammaries, Cindy Banks
Family Dog, Brad Bird
No Neck Joe, Craig McCracken
Gun, Zipper, Snot, The Unknown Animator
Performance Art Starring Chainsaw Bob, Brandon McKinney
Dog Pile, Miles Thompson
Dog Pile 2, Miles Thompson
Frog Baseball, Mike Judge
Wipeout, John Davis
Pink Komkommer, Alison Snowden and David Fine
Quiet Please, Mike Grimshaw
Sittin' Pretty, Mike Grimshaw
Buliminator, Teddy Newton and Craig Kellman
Sex Drive, Dan Lessin
Mutilator Episode: The Underworld, Eric Fogel
Woeful Willie, Chris Louden
Lupo the Butcher, Danny Antonucci
Deep Sympathy, Mike Grimshaw
Empty Roll, Miles Thompson

Discoveries, Dan Smith
Slipp'ry When Wet, Harrison Powers
Baby Boom, John A. Davis
Downbeat Dowager, John A. Davis
Bladder Trouble, Webster Colcord
Lullaby, Ken Bruce
Thank You Masked Man, John Magnuson
One Man's Instrument, Max Bannah
Inbred Jed's Honkey Problem, Mike Judge
Plastic Sex, Pierre Ayotte and Danielle Jovanovic

1993 (SICK & TWISTED)
Cocks, DNA Productions
The Cat, the Cow, and the Beautiful Fish, Walter Santucci
Phull Phrontal Phingers, Mike Wellins
Teddy's Revenge, Teresa Lang
Spaghetti Snot, Miles Thompson
Big Top, Mike and Theresa Pattengill
Stubs, Skippy Tracer
Poetic Jaundice, Tom Lamb and Dan Brisson
Art School for the Criminally Insane, Greg Brotherton/Spencer Strath
Gas Planet, Xaox
Petey's Wake, Walt Dohrm
A Hole in One, Dave Smith
Rex the Runt, Richard Goleszowski
Wastes Away, Anthony Lioi
Hut Sluts, Miles Thompson
Reaper Madness, Nick Donkin
Whoopass Stew, Craig McCracken

1994 (CLASSIC FESTIVAL OF ANMATION)
Iddy Biddy Beat, Mo Willems
Infra Red Roses Revisited, Xaos US
Rock Paper Scissors, Jeremy Cantor
Legacy, Darren Butts
The Wrong Trousers, Nick Park
Loves Me, Loves Me Not, Jeff Newitt
Trott, Matthias Bruhn
Brian's Brain, Miles Thompson
I Love You Too, Josko Marusic
Jurassic Park, Scott Nordlund/Mark Osborne
Personal Hell, Dana Hanna
Jean-Claude des Alpes, Ted Sieger
Better Than Grass, Bonnie Leick
The Village, Mark Baker
Ne C'est Pas, Sherrie Pollack
Le Criminal, Gianluigi Toccafondo
Britannia, Joanna Quinn
Blindscape, Stephen Palmer

1994 (SICK-A-THON)
My Dog Sex, Jimmy Cesario
In My Humble Opinion: TV Violence, Corky Quackenbush

Beastly Behaviour, Honeycomb Animation
Safe Sex, Greg Lawson
The Birth of Brian, Mellow Manor
One of These Days, Bill Plympton
Mutilator, Eric Fogel
Pull My Finger, Jay Hathaway
Lloyd's Lunch Box, Gregory Ecklund
The Evil Cat Does Washington, Walter Santucci
Home Honey, I'm High, Kevin Kalliher
Digital Time, Agave
Wastes Away, Anthony Lioi
Deadsey, David Anderson
Gogs, Jones & Morris
Wrong Hole, Mark Oftedal

1995 (CLASSIC FESTIVAL OF ANMATION)
Opposing Views, John Schnall
Mrs. Matisse, Deborah Solomon
Semper Idem, Joachim Bode
Sleepy Guy, Raman Hui
Triangle, Erica Russell
How to Make a Decision, Matthew Brunner
The Dirdy Birdy, John R. Dilworth
Bob's Birthday, Alison Snowden and David Fine
Crossroads, Raymund Krumme
Beastly Behaviour, Honeycomb Animation
The Janitor, Vanessa Schwartz
The Monk and the Fish, Michael Dudock de Wit
The Big Story, Tim Watts and David Stoten

1995 (SICK & TWISTED)
Abducted, Webster Colcord
The Preacher, Tony Nittoli
Smush, Jeff Vilencia
The Perfect Match, Dare Matheson
Hey, Phuck Yew, Bob McAfee
Watching TV, Chris Hinton
Lloyd Loses His Lunch, Gregory Ecklund
Bearded Clam, Tom Lamb and Dan Brisson
Safe Sex, Greg Lawson
Fly with the Wind, Gregory Ecklund
Adam's Other Rib, Eric Schneider
I Never Ho's For My Father, Tony Nittili
Little Girl and the Bear, Dare Matheson
One Ration Under God, DNA Productions
Take Your Pick, Paul Naas

1996 (CLASSIC FESTIVAL OF ANMATION)
Pacifier, Alexander Tatarsky
Nose Hair, Bill Plympton
Sophie, Matt Sheridan and Nancy Keegan
Passage, Raymund Krumme
Wat's Pig, Peter Lord

Gararin, Alexij Kharitidi
Three After Thoughts, Caroline Cruikshank
Do Nothing Till You Hear from Me, Pernilla Hindsefelt
Ah Pook Is Here, Philip Hunt
Fluffy, Doug Aberle
The End, Chris Landreth, Robin Bargar
Kebabluba, E. Tahsin Ozgur
A Close Shave, Nick Park
Big Dumb Fat Stupid Baby, David Donar
How to Make Love to a Woman, Bill Plympton

1996 (SICK & TWISTED)
Hello Dad, I'm in Jail, Christoph Simon
Condom Complaint, Corky Quackenbush
The Happy Moose, Walter Santucci
Blackhead and Weiner, Vancouver Film School
Ah l'Amour, Don Hertzfeldt
Baby's New Formula, Aaron Springer
Mary Lou, Todd Kurtzman, Danny Sharago, and Luke Longin
Shit-Faced, Clay Butler
The Lizard Whomper, T. Reid Norton
Left Over Dog, Channel 4
The Dye Dick, Dave Smith
Tasty Beef, David Thomas

1997 (ORIGINAL FESTIVAL OF ANIMATION)
Stiffy, Brian McPhail
Touched Alive, Stephen Arthur
Mona the Cat, Pjotr Sapegin
The Great Migration, Iourly Tcherenkov
Barflies, Greg Holland
The Devil Went Down to Georgia, Mike Johnson
The Tenor, Thor Freudenthal
Chessmaster Theatre, John Wardlaw and Michael Wilcox
Trainspotter, Jeff Newitt
Stressed, Karen Kelly
Hilary, Anthony Hodgson
Political Correction, Steven Fonti
Canhead, Tim Hittle

1998 (ORIGINAL FESTIVAL OF ANIMATION)
Shock, Zlatin Radev
Guten Appetite, Berad Beyreuther, Daniel Binder, and Robert A. Zwirner
Lily and Jim, Don Hertzfeldt
Underwear Stories, Blair Thornley
Museum, Rob Breyne, Nico Meulemans and Lef Goosens
Man's Best Friend, Ben Gluck
Fruhling, Silke Parzich

T.R.A.N.S.I.T., Piet Kroon
Welcome, Alexi Karaev
Hand in Hand, Lasse Persson
Geri's Game, Jan Pinkava

1998 (SICK & TWISTED)
The Spirit of Christmas, Matt Stone and Trey Parker
The Secrets of Flirting, Bob McAfee
Floss, Nica Lorber
Sick & Twisted Special Games, Steve Fonti
Frosty, Matt Stone and Trey Parker
Below the Belt, Liam Hogan and Trevor Watson
Beyond Grandpa, Breehn John Burns and Jason Johnson
Boris the Dog, Mad Dog Films
How to Use a Tampon, Gil Alkabetz
Monica Banana, Scott Roberts
Animalistic Times, Steve Margolis
How to Get Pronged, Steve Fonti
Stupid for Love, Craig Valde
Slick's Magnum, Bob King
Coco the Junkie Pimp, Pete Metzger
Karate Dick Boys, Brian Bress
Use Instructions, Guido Manuli
Jurassic Fart, Kendall Smith
Fast Driver, Nick Gibbons
Illusion of Life, Joddy Nicola and Steve Loizos
Smoking, Neil Ishimino
Sea Slugs, Adam Lane
Yes Timmy, There Is a Santa Claus, Steven Fonti
The Booby Trap, DNA Productions
Little Rude Riding Hood, Mike Grimshaw
Sloaches Fun House, Clayboy

1999 (CLASSIC FESTIVAL OF ANIMATION)
Pings, Pierre Coffin
Tightrope, Daniel Robichaud
The Blue Show, Peter Reynolds
Hum Drum, Peter Peake
The Man with Pendulous Arms, Laurent Goriard
The Art of Survival, Cassidu Curtis
Sientje, Chris Moesker
The Queen's Monastery, Emma Caulder
Son of Bambi Meets Godzilla, Eric Fernandes
VHX/Carrhot, Luc Otter
Balance, Christophe and Wolfgang Lauenstein
Busby, Anna Henckel-Donnermarck
Billy's Balloon, Don Hertzfeldt
The Romance of My Heart, Solweig von Kleist
Bingo, Chris Landreth
Bunny, Chris Wedge

1999 (SICK & TWISTED)
No Neck Joe, 3 DNA Productions
Die Harder in Two Minutes, Konstantin Bronzit
Tyson: I Am Not an Animal, David Lipson
Ballet Blues, Thomas Kung
Body Parts, Jonas Odell
Chicken Soup, Johnny Turco
Beat the Meatles, DNA Productions
Radioactive Crotch Man, Nuck Gibbons
Bowlin' for Souls, SuperGenius
Horned Gramma, Dave Foss
Legend of Raggot, Sean Scott
Grimm's Humpty Dumpty, Ryan Montrucchio
Swing Sluts, Brett Johnson
Beyond Grandpa II, Breehn John Burns and Jason Johnson
Tongue Twister, Sean Scott
The Beckers: Cannibalism and Your Teen, Natterjack Animation
Forrest Dump and Freskin Gump, Roy T. Wood
Surprise Cinema, Bill Plympton
Merry Christmas Grandma, Greg Kovacs
Home Honey, I'm Higher: What You Should Know About Drugs, Dan Dudley

2000 (SICK & TWISTED)
Radioactive Crotch Man, DNA Productions
Pussy Da Red Nosed Reindeer, Walter Santucci
Monkey vs. Robot, Geoff Marslett
Coco the Junkie Pimp, Michael Comas and Pete Metzger
Mute and Motormouth in Birth of Abomination, Jeff Pee and Chris Grahenburg
Rick and Steve: The Happiest Gay Couple in the World, Q. Allen Brocka
Stinky Monkey, David Lipson
Beat the Brat, Mad Dog Films
Angry Kid, Darren Walsh
The Hangnail, Shane Acker
Wheelchair Rebecca, Roy T. Wood
For the Birds, Ralph Eggleston
The Ghost of Stephen Foster, Raymond S. Persi and Matthew Nastuk
Rejected, Don Hertzfeldt

2001 (CLASSIC FESTIVAL OF ANIMATION)
Caged Birds Cannot Fly, Luis Briceno
The Pigeon and the Onion Pie, Stephen Holman and Josephine Huang
Drink, Patrick Smith

The Man with the Beautiful Eyes, Jonathan Hodgson
Ill Communication, Danny Capozzi
The Last Drawing of Canaletto, Cameron McNall
Father and Daughter, Michael Dudock de Wit
Europe and Italy, Bruno Bozzetto
Brother, Adam Elliot
Little Milosh, Jakub Pistecky
Hello Dolly, Mariko Hoshi
Insect Poetry, Marilyn Zornado
Metropopular, Jonah Hall
The Prince and the Princess, Michael Ocelot

2001 (SICK & TWISTED)
Behind the Music That Sucks—Britney Spears, Heavy.com
Timmy's Lessons in Nature, A&S Animation
Eat, Bill Plympton
Maakies, Tony Millionaire
Thank You, Masked Man, John Magnuson
Hello Dad, I'm in Jail, Christoph Simon
Bad Phone Sex, Howie Hoffman with Stephen Kroninger
F*@# Her Gently, featuring Tenacious D, directed by Spumco, Inc.
Love That Pussy, DNA Productions
Harry Pothead and the Magical Herb, Los Primos Productions
Voltron and Heroin, Mad Dog Films
When Chickens Attack, David Phillips
Of Mice and Men and Mama Cass, Cody Critcheloe
Pornoless, Martin Georgiev
An Old Story, Zohar Shahar
Choke, Spot, Choke, Brice Beckham
Behind the Music That Sucks—Eminem, Heavy.com

2002 (BEST OF THE FEST)
Mona the Cat, Pjotr Sapegin
Rope Dance, Raimund Krumme
Your Face, Bill Plympton
The Prince and the Princess, Michael Ocelot
Bunny, Chris Wedge
The Janitor, Vanessa Schwartz
Bob's Birthday, Alison Snowden and David Fine
Tin Toy, John Lasseter
Bambi Meets Godzilla, Marv Newland
Screenplay, Barry Purves
The Great Cognito, Barry Bruce
Grasshoppers, Bruno Bozzetto

Balance, Chistophe and Wolfgang Lauenstein
Creature Comforts, Nick Park
The Devil Came Down to Georgia, Mike Johnson
For the Birds, Ralph Eggleston

2002 (SICK & TWISTED)
Cubism, Jason Baskin
Happy Tree Friends: Meat Me for Lunch, Mondo Mini Shows
The Inbreds, Cosgrove Hall Films
Chump, Sam Fell
Teach Me, Karl Wills
Nougat Part 2, William Fiala and Tibor Szakaly
Happy Tree Friends: Hide and Seek, Mondo Mini Shows
The Dolls, Kiyoshi Kohatsu
Happy Tree Friends: Sweet Ride, Mondo Mini Shows
Coco the Junkie Pimp, Michael Comas and Pete Metzger
The Three Pigs, Mike Gray
1300cc, Eoin Lake
Pickle's Day Out, Marc Wilson and Robert Darling
Five F*#king Fables, Signe Baumane
Osama Claus, Steve Baggs
Gack Gack, Olaf Encke
Nougat Part 1, William Fiala and Tibor Szakaly
Refrigerator Art, Michael Doughtery
Happy Tree Friends: Spin Fun Knowin' Ya, Mondo Mini Shows
Pass It On, Chad Strawderman
Happy Tree Friends: Chip off the Old Block, Mondo Mini Shows
A Father and Son Chat, Darren Way
Roofsex, PES
Happy Tree Friends: Boo Do You Think You Are, Mondo Mini Shows
Shh, Adam Robb
Happy Tree Friends: It's a Snap, Mondo Mini Shows
Six New Vignettes, Bill Plympton
F*@# Her Gently, featuring Tenacious D, directed by Spumco, Inc.
Happy Tree Friends: Crazy Antics, Mondo Mini Shows

CREDITS

All images copyright © Spike & Mike
unless noted below:

Front cover: © Danny Antonucci/International
Rocketship; (inset) © Stretch Films
Back cover: © MTV Networks
1: © Marv Newland/International Rocketship
2: © Spike & Mike
3: © Danny Antonucci/International Rocketship
4–5: © Pixar Animation Studios
10: Photo by Bob Ringquist /© The Press Enterprise
26, 29: © King Features/Fleischer Studios
30, 33: © Turner Entertainment
34: © Classic Media
35: © Aurica Finance Company
36: © Sally Cruikshank
38: © Canadian Broadcasting Company
39: © Italtoons
40–41: © Sally Cruikshank
42: © Michael Dudok de Wit
43: *Elbowing* © Société Radio-Canada; *The
Water People* © Nico Crama Films; *Three
Misses* © Channel 4 & Arte
44: © Zagreb Film
45: © National Film Board of Canada
46: © Natonal Film Board of Canada
47: © A Bare Beards Film for Channel 4 Televi-
sion. *Achilles* photo Paul Smith; *Screenplay*
photo Mark Stewart
48: *Girls' Night Out* © Middlesex Polytechnic/
Channel 4/S4C; *Body Beautiful* © S4C/Channel 4
49: © Tezuka Productions
50: © Will Vinton Studios
51: © Richard Williams
52: © Zagreb Studio
53: © Pannonia Studio
54: *Beavis and Butt-head* © MTV Networks
55: © Danny Antonucci/International Rocketship
56–57: © Marv Newland/International Rocketship
58–59: © MTV Networks
60–61: *South Park* © Comedy Central
62–63: © Bill Plympton
64–65: © Danny Antonucci/International
Rocketship
66–67: © Don Herzfeldt/Bitter Films
68–69: © Aardman Animations Ltd. 1989
70–71: © Pixar Animation Studios
72–73: © Craig McCracken
74–75: © Stretch Films
76: © Cindy Banks/Spike & Mike
78: *Charade* © Jon Minnis; *Apprentice*
© National Film Board of Canada
79: © Mo Willems
80: © Mike Mitchell
81: *Ghost of Stephen Foster* © Mammoth Records;

Give AIDS the Freeze! © Cathy Joritz
82–83: © Shane Acker
84: *The Cat, the Cow, and the Beautiful Fish*
© Walter Santucci; *Empty Roll* © Miles
Thompson
85: © National Film Board of Canada
86: © Spike & Mike
87: © Pixar Animation Studios
88: C. Landreth
89: © Spike & Mike
90: © Cindy Banks
91: *Grinning Evil Death* © Mike McKenna and
Bob Sabiston; *She-Bop* © Joanna Priestley
92: *The Arnold Waltz* © Craig Bartlett; *Second
Class Mail* © National Film and TV School
93: © Viacom
94: © National Film Board of Canada
95: *A Greek Tragedy* © CinéTé; *Next Door*
© Pete Docter
96: *My Dog Zero* © Joe Murray; *Cocks* © DNA
Productions
97: © Tandem Films
98: © Batty Berry MacKinnon Productions
99: *Bunny* © Blue Sky; *Balance* © Christoph
and Wolfgang Lauenstein
100: © 1993 DNA Productions
101: © Brett Koth
102: © Joan Gratz
103: *I Was a Thanksgiving Turkey* © 1986 John
Schnall; *Cat and Mouse* © Colossal Pictures
104: *Kakania* © Karen Aqua; *Rick the Dick*
© Spike & Mike
105: © Deborah Solomon
106, 108, 110, 111: © Bill Plympton
112, 113: © MTV Networks
114, 115: © Mike Judge
116–117: *The Powerpuff Girls* © Cartoon Network
1992. An AOL Time Warner Company. All
Rights Reserved
119, 120, 121: © Pixar Animation Studios
122: Alison Snowden and David Fine/Interna-
tional Rocketship
123, 125, 126: © Marv Newland/International
Rocketship
127, 128, 129: © Don Herzfeldt/Bitter Films
130: © Channel Four Television Corporation 1996
131: © Aardman Animations Ltd. 1991
132: © Aardman Animations Ltd. 2001
133: © NFTS 1989
134: © Aardman Animations Ltd. 1995
135: *Morph* © Aardman Animations Ltd. 1995;
Creature Comforts © Aardman Animations
Ltd. 1989
136–37: © Aardman Animations Ltd. 1999
138, 140: © Danny Antonucci
141, 143: © Andrew Stanton
144–51: © Spike & Mike

ACKNOWLEDGMENTS

Jerry Beck and Spike Decker would like to
thank the animators who generously gave their
time and loaned rare artwork to this project:
Danny Antonucci, Pete Docter, John Dilworth,
John Lasseter, Peter Lord, Nick Park, Craig
McCracken, Marv Newland, Bill Plympton, and
Andrew Stanton.

For sharing their personal memories of
Spike & Mike, they must thank Marilyn Zornado,
Todd McFarlane, Shane Reiley, Shawn Peterson,
Chris Padilla, Bob Kurtz, Libby Simon, Steve
Harman, and the staff at Mellow Manor, espe-
cially Sara Henson and Marc Ziccardi.

Terry Thoren (for being a good sport) and
everyone at Pixar (for being cool) deserve spe-
cial mention.

The author could not have put this book
together without the input and support of friends
Marea Boylan, John Canemaker, Leonard Maltin,
Heather Kenyon and Darlene Chan at AWN,
Mike Mallory, Rita Street, Courtney Purcell,
Helene Tanguay, Bill Vallely, and the loyal read-
ers of www.cartoonresearch.com.

Elisa Urbanelli and Ellen Nygaard at
Abrams, Alan Novins at The Firm, and Aaron
Berger of Animanagement merit thanks for their
expertise and extreme patience.

And special thanks go to David and Lillian
Decker, Scott "Haireball" Haire for being the title
holder as the longest Spike & Mike employee,
Holmes Walton, John and Nancy Lasseter, Joey
Tague for selling tickets at age six, Ellen Gold-
smith, Margene Scott, "Weird Al" Yankovic, Ellen
"Barkie" Holty, Medeia "The Well-Endowed Ital-
ian," Irish Katorama, Catalina, Todd Stern,
Heather "The Hottie," Paul "The Dreez" Driessen,
Oscar "The Best Damn Artist" Grillo, DNA, David
Sproxton, Jason at True Art Tatoo, Mark Kausler,
Marc Levine, and Melissa Madonna, the Gotham
Group, and Ferdinand Lewis.

INDEX

Editor: Elisa Urbanelli
Designer: Ellen Nygaard Ford
Production Manager: Justine Keefe

Library of Congress Cataloging-in-Publication Data

Beck, Jerry.
 Outlaw animation : cutting-edge cartoons from
the Spike & Mike Festivals / Jerry Beck ; foreword
by Todd McFarlane.
 p. cm.
Includes index.
 ISBN 0-8109-9151-9 (pbk.)
 1. Animated films—United States. 2. Independent
filmmakers—United States. I. Title: Cutting-edge
cartoons from the Spike & Mike Festivals. II. Title.

NC1766.U5 B43 2003
791.43'3—dc21

 2002151676

Harry N. Abrams, Inc.
100 Fifth Avenue
New York, N.Y. 10011
www.abramsbooks.com

Abrams is a subsidiary of

LA MARTINIÈRE
G R O U P E